LOST VILLAGES OF SUSSEX

ALEX VINCENT

AMBERLEY

Acknowledgements

I wish to thank those who have helped with the research for this book and the Sussex Archaeological Society, County Archaeologists of the East and West Sussex County Councils for the use of their archives and libraries. I also wish to thank those other people and friends for the help they have given me with their useful knowledge and information. Special thanks also go to Con Ainsworth, Charles Walker and Martin Snow for their help.

First published 2020

Amberley Publishing, The Hill, Stroud
Gloucestershire GL5 4EP

www.amberley-books.com

British Library Cataloguing in Publication Data.
A catalogue record for this book is available from the British Library.

ISBN 978 1 4456 9820 5 (print)
ISBN 978 1 4456 9821 2 (ebook)

Typesetting by Aura Technology and Software Services, India.
Printed in Great Britain.

CONTENTS

Introduction

Throughout England there are more than 3,000 deserted medieval villages (DMVs). Most were lost during the Black Death or bubonic plague, which spread throughout the country in the mid-fourteenth century. Many people died and others moved into neighbouring villages. Besides the Black Death there were also other plagues, which caused village desertion such as in the seventeenth century. In some cases a village was pulled down to enlarge a park to give privacy to a big house such as at Wiston and Parham in Sussex. This is known as emparking.

A number of deserted medieval villages are visible today as earthworks in the form of hollow ways, house platforms, mounds, etc., in fields. Some sites have been extensively ploughed, destroying earthworks, or built over by the growth of a nearby town. Foundations of buildings are sometimes visible as cropmarks where the crops show discolouration and, in some cases as earth marks in dry weather. Many sites were discovered during very hot summers, particularly that of 1976.

Other villages have been lost out at sea; the most famous case is that at Dunwich in Suffolk, which was an important Saxon town. There has been a lot of coastal erosion along the east coast of England. Not many deserted medieval villages have been excavated, although Wharram Percy in Yorkshire, which is a well-known lost village, has been excavated every summer since 1950.

As well as deserted villages there are shrunken and shifted villages. The shrunken villages were once larger places and reduced in size. Shifted villages are where the village was resited from its original site. In the case of some shifted or migrated villages the church stands by itself some way from the village.

Not all deserted medieval villages can be traced to the Black Death, as their desertions are uncertain. Most of the lost villages in Sussex are either coastal or downland, but there are very few in the Weald. The Weald is still very wooded and so Wealden villages tend to be mainly scattered settlements. It is possible that woodland was cleared in the Weald to build houses in and around the church. When the villages were deserted, the area reverted back to woodland, making archaeological fieldwork difficult on the sites. Downland and coastal areas mainly became farmland for grazing or agriculture after the village was lost.

During plagues, a number of pesthouses or isolation hospitals were built throughout the country to quarantine or imprison victims. Some buildings may have been converted to be used as a pesthouse. The name pesthouse is defined as a hospital for plague victims. They were in absolute isolation until they died or in rare cases recovered. People who caught the disease and those suspected of it were imprisoned therein.

For centuries, any group of cottages on the outskirts of a town or village with an adjoining chapel would suggest to the local traveller to be the local pesthouse. Samuel Pepys refers to pesthouses (also pestcoaches) in his diaries for 1660 to 1669, which is the time of the Great Plague of London, which raged in the summer of 1665.

The earliest recorded mention of earthworks in Sussex was those at Kingston near Ferring in September 1848. A. Hussey noticed them near the presumed site of Kingston chapel. Other sites were recorded in the nineteenth century, such as at Parham in 1870 by W. Cooper. Three villages have been accepted on the author's evidence as shrunken and deserted by the Medieval Settlement Research Group (MSRG). The places are at Kingston near Ferring, Hurstpierpoint north of Brighton and Tortington near Arundel, where the author noticed earthworks.

Several sites were excavated, the most extensive being at Hangleton before the site was swallowed up by the growth of Hove and Brighton. In a few cases only the church was excavated, like those at Bargham and Exceat. The Sussex coast has suffered changes due to encroachments of the sea, which overwhelmed towns and villages. Rye and Winchelsea were originally built on islands and Rye is now 2 miles inland. The old town of Winchelsea was engulfed by the sea in the thirteenth century.

Some sites are now preserved such as at Monkton near Chichester and other places throughout the country, which have very good earthworks and are Scheduled Ancient Monuments. A number of lost villages are on private land and permission must be sought before entering onto it. Some lost villages are now only represented by a farm.

There could be many more lost villages waiting to be discovered and there has probably been a period of desertion in most villages over the centuries. In some cases, a village may have been deserted due to the Black Death, but resettled on its original site instead of being built on a new one. One case may be at Stoughton in Sussex where the existing houses near the church date from only the seventeenth century. In the case of shrunken villages, others may exist and one case may be at North Mundham in Sussex where most of the houses around the church are modern, but these may have replaced older buildings.

This book gives details about the lost villages in Sussex and what earthworks of the former sites exist, if any. The lost villages in Sussex are given in three parts. The first part is deserted villages where there are only a few houses and a church still standing or nothing at all. The second part is the shrunken villages and the third part is the shifted villages. Each village is given a grid reference and where the site is uncertain then an approximate one is given.

All photographs and map are by the author.

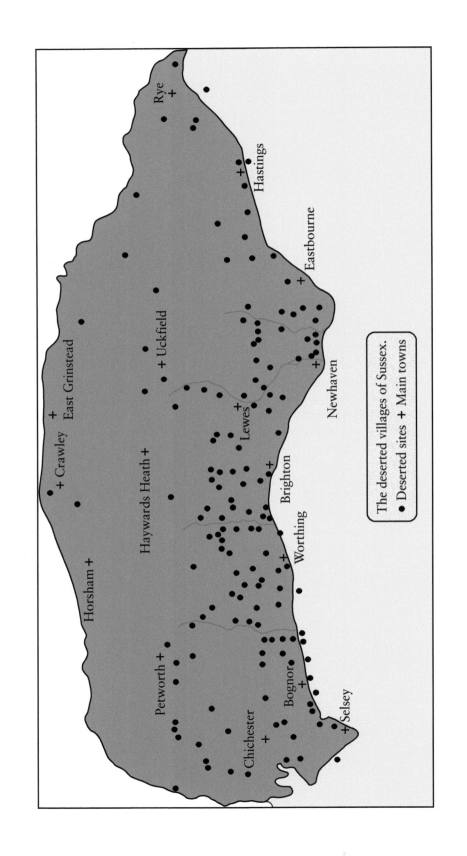

The deserted villages of Sussex.
• Deserted sites + Main towns

Rye
Hastings
Eastbourne
Uckfield
East Grinstead
Crawley
Haywards Heath
Lewes
Newhaven
Brighton
Horsham
Worthing
Petworth
Bognor
Selsey
Chichester

DESERTED VILLAGES

Aldrington

OS Grid Ref TQ 266 053

The village of Aldrington was mainly lost due to coastal erosion, but the scour of the River Adur (which at one time entered the sea at Aldrington) also led to the desertion of the village. The remaining houses in the village were destroyed by storms in 1703 and 1705 and the church, which was neglected in 1586, was in ruins. Aldrington was attacked by the French in 1514. The old village site was developed on in the nineteenth century and the ruined church was rebuilt.

Applesham

OS Grid Ref TQ 185 072

The hamlet of Applesham in the parish of Coombes was mentioned in the Domesday Book where a mill was recorded. It also has two salterns in 1086 where salt making was the only industry recorded in the parish. No church is mentioned,

Farm on site of the lost village, Applesham.

but there may have been a chapel of ease at Applesham in 1261. The desertion of the hamlet was probably in the Middle Ages. On the site today are a few bumps in fields in the vicinity of Applesham Farm.

Apuldram

OS Grid Ref SU 842 033
There was a village around the area of the thirteenth-century church in Apuldram when monks surveyed it in 1433. The village clustered around four streets that converged at crossroads and one of the streets, 'Ystrete', may be the present Birdham Road. Apuldram also had a small harbour that has disappeared and the silting of the Chichester channel in the Middle Ages may have caused the desertion of Apuldram village.

Today there are disturbances in fields south of the church and west of the fifteenth-century Rymans House. Two of the streets mentioned above have now become footpaths. In 1954 a great number of skeletons were discovered in the Dell Quay mud and may be linked to the mortalities of the Black Death. Dell Quay was the seventh most important port in medieval times and is also the smallest.

Rymans House.

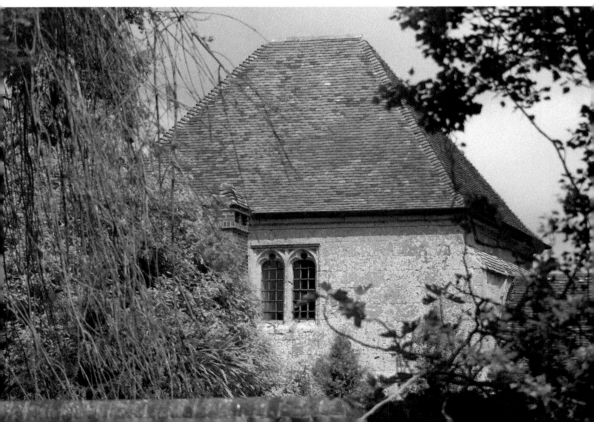

Mass dial from old church
now at Bailiffscourt chapel.

Atherington

OS Grid Ref *c.* TQ 007 007

The village of Atherington and its church are now lost to sea due to coastal erosion.
The sea encroached on land some time at the end of the seventeenth century. It is
said that the ruins of the church can be seen at low tides and that the bell can be
heard ringing at certain times of the year. The only remains of the village today
are Atherington Cottages and barns at the end of Climping Street. This lane leads
out to the sea and Bread Lane probably joined it some 200 yards out. This was the
presumed site of Cudlow village and church, now in the sea.

Around a quarter of a mile north of Climping Beach is Bailiffscourt, which has
a thirteenth-century chapel. In the south-east outside corner there is a stone with a
medieval mass dial scratched on it. Some years ago this was washed up by the sea
and probably came from the submerged Athrington church. John Norden's map
of 1606 of Atherington manor shows Atherington, south-west of Bailiffscourt,
in a position under the sea. It is said that Atherington never possessed a church
and that the chapel of Bailiffscourt was probably a hamlet chapel, which served
Atherington as well as being a manorial chapel. It is possible that the chapel was
used as a hamlet chapel when Atherington church was lost.

Balmer

OS Grid Ref TQ 359 102

The village or hamlet of Balmer was probably a small place and had a chapel.
Today there is only a farm and a few houses on the site. The date of desertion is
uncertain, but was probably due to the Black Death. A number of earthworks
can be seen on the site today. In a field north of Balmer Farm and west of the
farm pigsties are building sites that may be of medieval origin. Also, remains
of buildings near the modern farm buildings may have been built on the site of
medieval ones. Traces of other buildings can be seen on Upper Green Field.

Balmer chapel, which was mentioned in the Domesday Book of 1086 (where
a small church is recorded), disappeared a long time ago and its site is uncertain,

Site of the lost village of Balmer in field showing slight earthworks.

but it probably stood to the west of the pond and there is a Church Laine Field, which is the field going southwards towards the main A27 Brighton to Lewes road. The chapel was not mentioned in the records of the state of the diocese of Chichester, 1563, and was probably in ruins before this. It was probably in a state of disrepair by the middle of the fourteenth century when the village was deserted.

Balsdean

OS Grid Ref TQ 378 059
Balsdean is around 2 miles north of Rottingdean and the desertion of the hamlet is uncertain. There are poor earthworks on the site today. There were two farms in the valley before 1939, one of which is Balsdean, which had an eighteenth-century

Stone marking site of chapel altar, Balsdean.

farmhouse, two cottages and a group of farm buildings. These buildings were destroyed in 1943 and not long after the war the sites were cleared of rubble and levelled, including the twelfth-century chapel. The site of the medieval Balsdean manor is uncertain. A plaque marks the site of the chapel's altar today.

Bargham

OS Grid Ref TQ 067 089

The village of Bargham was probably deserted at the time of the Black Death in the mid-fourteenth century. On the site today known as Upper Barpham is a seventeenth-century farmhouse, farm, pond and opposite the farm is the site of the church in a field called Chapel Croft. There are only vague bumps on the site today and irregularities in a field near the farmhouse. No signs of the old village could be seen from aerial photographs.

The site of the Saxon church, which was pulled down in the early part of the sixteenth century, was excavated in the 1950s after brambles and overgrowth were cleared. Many items were found such as Horsham slab, a priest's doorway on the south wall of the chancel, graves and fragments of a font. The site of the church is marked by a mound.

Hollow way of the main street with earthworks in the vicinity, Bargham.

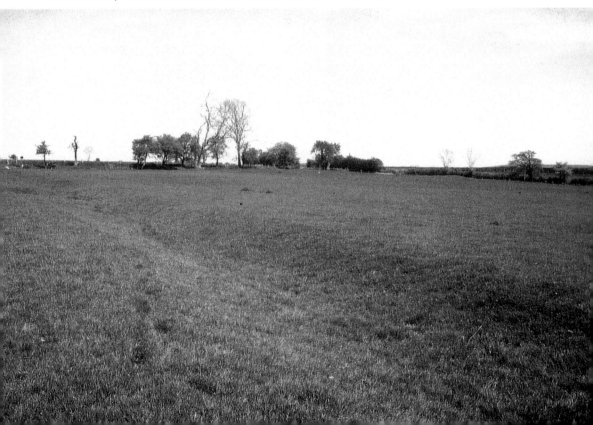

Barkham

OS Grid Ref TQ 439 217

There are faint earthworks and possible house platforms in a field west of Barkham manor, which may be the site of a possible DMV. The next field is known as 'Church Field', which suggests that a church or chapel existed here. Barkham manor dates from 1838 and was built on the site of the old manor in the Domesday Book. North of this are a barn and oast house dating from the eighteenth century.

Barnhorne

OS Grid Ref TQ 695 078

The village west of Barnhorne, north of Bexhill, was deserted sometime in the Middle Ages. A furnace was mentioned at Barnhorne in 1306 and in 1307 the manor is recorded as having 400 acres of farmland with a dovecote and windmill. The windmill survives today as a mound. The site of the deserted village has been ploughed and no sign can be seen of the earthworks. Medieval roofing slate was found in a trench, which had cut through the remains of a building. Little evidence survives today for the existence of the village.

Bepton

OS Grid Ref SU 855 183

This village was probably deserted due to the Black Death of the mid-fourteenth century. Only a church and farm buildings exist at Bepton today. There are earthworks in fields in the area of the church, which may represent the site of former houses. In the churchyard, south of the church between the tower and an old oak tree under shrubbery, is a mass grave of plague victims.

Bidlington

OS Grid Ref TQ 182 103

Bidlington, near Bramber, is a lost hamlet and had a church, which was mentioned in 1269 including its cemetery. The church no longer existed in the seventeenth century. There was a leper hospital at Bidlington dating from the early thirteenth century and the first reference to it dates from 1220. The hospital, which was built close to the church, was dedicated to St Mary Magdalen and probably ceased to be used sometime in the seventeenth century.

The site is in Maudlin Lane, which was a high road in medieval times. No sign can be seen of the hamlet today apart from Maudlin Farm, which was once Bidlington manor house. The church and hospital stood on the north side of Maudlin Lane and Maudlin House was built on the site. During excavations before development occurred to the west, thirty skeletons and medieval pottery were found. This is the site of the leper cemetery, which may have been the burial ground to the hospital. The area is now built over and Maudlyn Parkway occupies the site of the cemetery.

Bilsham

OS Grid Ref SU 973 022
Bilsham is around a mile south of Yapton and the hamlet was deserted at some unknown date. On the site today are the manor house, thirteenth-century chapel and Old Bilsham Farm west of the chapel. There are earthworks and disturbances north-west and south of the old chapel, which probably represent house sites. The chapel is now a private house.

Binderton

OS Grid Ref SU 851 108
Binderton, north of Chichester, was deserted in the seventeenth century and there are only vague bumps on the site today. Binderton House, farm and chapel remain. The old parish church stood in the present garden of Binderton House, just south of Binderton Lane. Thomas Smith had demolished it in around 1660 because it would interfere with the view of the house he planned to build. The house was built in 1677 on the site of the medieval village. The present Binderton chapel was erected by Thomas Smith's son, also named Thomas, in around 1671 to replace the old parish church. This is now a ruin.

Birling

OS Grid Ref TV 557 969
Birling, near East Dean, is a possible lost village or hamlet and there are a few earthworks on the site today to the north-west of Birling Farm. Birling once had a chapel of which there are no remains to be seen and was situated a little south-west of the farm on the other side of the road. The farm, now Birling manor, probably dates to the sixteenth century and one of the farm buildings is believed to be a thirteenth-century hall house.

Bivelham

OS Grid Ref TQ 631 264
The village of Bivelham existed between 1296 and 1524, but was deserted sometime before 1624. On the site today is Bivelham Farm, north of the River Rother, and further east is Bivelham Forge Farm. The grid reference given refers to the former and is around 3 miles east of Mayfield. Bivelham is sometimes spelled 'Bibleham'. There is no trace of the village today.

Botolphs

OS Grid Ref TQ 194 092
Botolphs, near Steyning, was a flourishing village and was concerned with shipping, which came up the wide Adur Estuary and had its own wharf. When this stretch of water shrank to create a narrower channel, the old bridge was destroyed. This bridge crossed the River Adur near the church and is said to have been built by the Romans to carry the tin road, which linked the Cornish tin mines with Pevensey. Botolphs served Annington manor, which is mentioned in the Domesday Book.

The village lost its prosperity and was deserted sometime in the Middle Ages, and in the field on the west side of the road opposite the church are mounds and inequalities where the village once stood. Excavations were carried out near the church and the sunken building of a manor house, rubbish pits and a scatter of pottery dating from the twelfth to fourteenth centuries were found.

A church known as St Peter de Vertere Ponte ('of the old bridge') was built in the eighth century and its location is not known. The present church of St Botolphs was in fact built on the site of it. The Domesday Book mentions a church at Hanyngedune, which is Annington, that had a manor of around 800 acres. This leads one to suppose that a church existed near the present manor house. It is evident that no church at Annington existed apart from St Peter de Vertere Ponte. The original name of Botolphs was Annington and got its present name from the church's dedication.

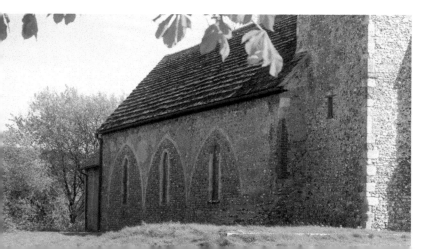

Site of north aisle, Botolphs.

The south wall of the nave and chancel arch and wall are Saxon. A north aisle was added in around 1250, and not long after the Saxon apse was replaced by the present chancel and a tower was added. The church today consists of tower, nave, chancel and south porch. The north aisle was removed probably after the village was deserted, but the pillars still remain.

Bracklesham

OS Grid Ref *c*. SZ 805 964
Bracklesham was lost to sea due to coastal erosion sometime in the sixteenth or seventeenth century. There were only five householders in the village in 1428. There was a chapel at Bracklesham, which is said to have had few parishioners if any by 1518 and was in a totally dilapidated state by 1815 according to Dallaway, but the site was probably unknown by that time because it was either under the sea or near Bracklesham Farm. This is a seventeenth-century house and may have been built on medieval foundations.

Broomhill

OS Grid Ref TQ 988 183
The village of Broomhill was destroyed by coastal erosion and silting caused the desertion of Broomhill over a period of centuries. The great storms of 1284–87 caused the main damage and between 1474 and 1478 large parts of land between Rye and Romney were in danger of encroachment by the sea. During the next two centuries other inundations occurred and the church was in ruins by 1637. John Berrye lost 1,162 sheep when the sea broke through in 1570. Broomhill was originally in Kent and was transferred to Sussex in 1895.

The site of Broomhill church is shown on recent maps, but services ceased after 1524 when inroads from the sea ruined it. There are no visible remains of Broomhill village to be seen today except that the site of the church is indicated by a few stones. The plan of the church was recovered during excavations and evidence for substantial flooding in the area since the thirteenth century was found. This was indicated by silt overlying the floor.

Buckham

OS Grid Ref TQ 452 206
Buckham was an early settlement and lies around 1.5 miles north of Isfield. The date of the desertion of the village is uncertain and the site is south of Beeches Farm. This farm was at one time known as Buckham Farm. Today there are

earthworks on the site such as banks, bumps, ditches and a hollow way, which runs across a field from the present road at Buckham Hill.

The earthworks are south of an abandoned railway cutting. An old quarry south of the earthworks has destroyed others, and a sign of human occupation may have been at the western end of the hollow way as bits of early medieval pottery were found, having been turned up by moles. Two ponds and a well existed on the site.

Buddington

OS Grid Ref TQ 161 122
Buddington hamlet is thought to have been deserted at the time of the Black Death and there were only a few inhabitants left early in the sixteenth century. Buddington declined to a farm sometime afterwards. On the site today there are earthworks on either side of a track between Lower Buddington and Round Robin Lodge. Several fields in the area have been ploughed. Buddington is around half a mile east of Wiston House near Steyning.

Bulverhythe

OS Grid Ref TQ 768 082
Bulverhythe was Burgher's landing place and was the main harbour to the folk of Hastings until the end of the fifteenth century. It was one of the limbs of the Cinque Ports of Hastings. By the end of the seventeenth century most of Bulverhythe was lost to sea by coastal erosion. The only remains of the original town are the Bull Inn and the church, which is in ruins. The area around the church is now built over.

The church dates from the fourteenth century, but there are traces of the original Norman church and thirteenth-century work. On the north side of the nave is a section of a Norman arch. The existing ruins are probably of the third church built on the site. Excavations were carried out at the church and a human skull and remains of a skeleton dating to the Middle Ages were found.

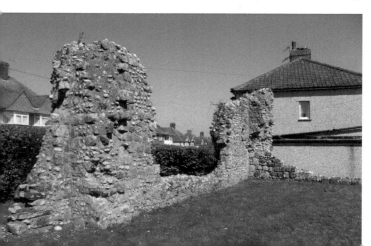

Ruins of the fourteenth-century church, Bulverhythe.

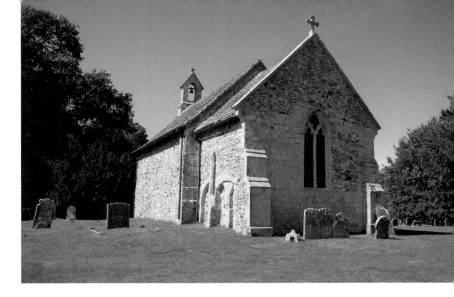

The old chapel,
Buncton.

Buncton

OS Grid Ref TQ 144 138

The hamlet of Buncton between Washington and Steyning had declined by 1622.
Earthworks of house sites are visible north-west of the chapel and disturbances west
of the road to Ashington, but there are no visible earthworks on the hill around
the isolated chapel. There are only a few other buildings some way north of the
eleventh-century chapel. There are earthworks of the old village in Spithandle Lane.

Burton

OS Grid Ref SU 967 176

The desertion of this village was due to the plague in the fourteenth century. There
is only a house with outbuildings and an eleventh-century church on the site
today. Sherds of well-fired ware and other ware were found here. There are no
visible remains of the village to be seen around the church.

Charleston

OS Grid Ref TQ 491 069

Charleston, near West Firle, was a small vill in the Domesday Book and was
known as Charlaxton in 1401. The desertion of the village is uncertain, but it was
only a farm by the seventeenth century. On the site today there are earthworks,
bumps and irregularities east of Charleston Farm, which may represent the site of
the village. There is a narrow earthen embankment on the site, which may have
been a lane.

Farmhouse on site of the village, Charleston.

Charlston

OS Grid Ref TQ 521 007

Charlston, near West Dean, was a small vill in the Domesday Book. Its desertion is uncertain, but by the sixteenth century it was only a farm. There are no signs of the village visible today and the area south of Charleston manor is wooded. Charlston is also known as Charleston and there was once a chapel there.

Charlton

OS Grid Ref TQ 168 117

This Charlton lies around a mile west of Steyning and was called a vill in medieval times. Its desertion was probably due to the Black Death, although there were still a few houses remaining in 1639. On the site today traces of the village are visible as bumps and humps in fields south of Charlton Court. Some earthworks also exist south of Mouse Lane. Some of the disturbances in the ground may represent house sites north and east of Charlton Court.

Charlton

OS Grid Ref c. SZ 901 971

Charlton was a Saxon tithing of Pagham and is first mentioned in the pre-Norman Conquest charter as 'Ceorla-tun'. The hamlet was swallowed up by the sea in the sixteenth century, but in the absence of documentary material it is difficult to be precise about when it was overcome. It certainly was lost by the eighteenth century. There is a road at Pagham (Sea Lane), which goes in a south-easterly direction to the sea, and a road called Barrack Lane, which reaches the sea in a south-westerly direction from Aldwick, and both lead to Charlton. These lanes converge at around 800 yards from the present shoreline.

Farm and dovecote on the site of former village, Chinting.

Chinting

OS Grid Ref TV 506 986
Chinting, east of Seaford, was a flourishing village in the thirteenth century. The village was deserted sometime during the Black Death or a little later. Chinting was just a farm by the seventeenth century and the village once had a chapel. On the site today are Chinting House, a dovecote, a farm and some bungalows converted from old barns in 1982. Chinting House is mainly eighteenth century, but has a medieval origin. There are a few earthworks of the old village on the site today.

Coombes

OS Grid Ref TQ 191 082
The village of Coombes, which was a large settlement in 1086, declined in the Middle Ages and by 1677 there were only twelve buildings left. Only a few exist at Coombes today. The church can only be reached by a footpath through a field, and the present village street to the farm at one time went right up to it. The roads, which are shown on a 1677 map, existed as tracks in 1875, but all save one have since gone.

In an adjacent field south-east of the church are a hollow way and house platforms, which indicate the former extent of the village. Coombes farmhouse dates from the seventeenth century and other buildings, which are mainly cottages, were built at a later date.

Earthworks of former village in field near the church, Coombes.

Cudlow

OS Grid Ref *c*. TQ 002 004
The village of Cudlow and its church are now under the sea. Cudlow was a sizeable place in 1540 but by the end of the sixteenth century the village was drowned by the waves. By this time the church was almost ruined, but still stood until it also was engulfed by the sea. The church was disused since the sixteenth century and the last rector was Thomas Hall in 1546. Cudlow was a port and a fishing centre.

The exact position of the village is unknown, although it is said that it is some 200 yards out at sea due south of Bailiffscourt's buildings, this being west of Climping Street. To the east of the street is a footpath that was once Bread Lane and probably dates back to when Cudlow was a thriving village. Climping Street and Bread Lane may have joined each other in the village of Cudlow. The only remains of the village today are Cudlow Barn, which is south-west of the Bailiffscourt buildings.

In September 1961 three teenagers discovered part of a tombstone and a wall while trying to locate the site of the old village. They saw six blocks of masonry covering an area 10 × 10 yards and appeared to be of Caen stone, which is often used in church building. They were unable to bring the rocks to the surface.

Daleham

OS Grid Ref TQ 442 246
Daleham, near Fletching, is a possible deserted medieval village. There are sites of medieval houses near the fifteenth-century Dalehamme House. In the field north of the house are earthworks in the form of irregularities and bumps.

Remains of priory next to the church, Denton.

Denton

OS Grid Ref TQ 454 025

The village of Denton was probably deserted at the time of the Black Death in the mid-fourteenth century. Only a couple of houses, a pub and church remain today. There are no other traces of the former village visible today, as the site has been largely built over by the growth of nearby Newhaven. West of the church are the ruins of a thirteenth-century priest's house, which was built of flint.

Didling

OS Grid Ref SU 836 181

The church at Didling stands by itself down a small lane and is known as 'The Shepherds Church' because shepherds used it as a place of worship while tending their sheep on the South Downs. It is possible that a village once existed

The Shepherd's Church, Didling.

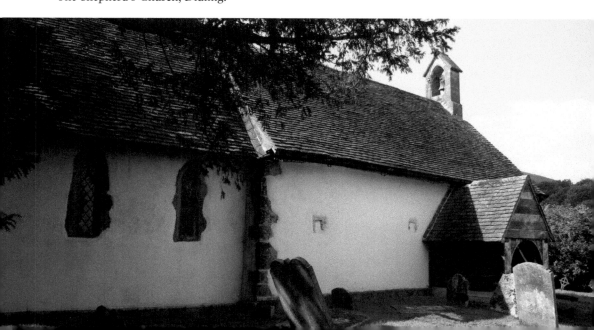

around the church and may have been lost due to the plague in the fourteenth century. There are only slight humps and irregularities in fields to the west and south of the church.

Downley

OS Grid Ref SU 752 179
Downley, on the Sussex-Hampshire border, is a possible deserted medieval village or hamlet. Thirteenth-century pottery, oyster shells, tiles and flints have been found on the site. The area has since been ploughed and woodland to the west has been cleared. The old hedge marking the county boundary has been removed. There are possible house platforms on the site.

East Itchenor

OS Grid Ref *c.* SU 801 005
Very little is known of the history of East Itchenor village, which was deserted sometime in the Middle Ages. The location of the village is unknown and no document or tradition indicates its site. East Itchenor must have been somewhere east of West Itchenor and north of Shipton Green. Its church was in ruins by 1441 and was demolished in the eighteenth century.

Ecclesden

OS Grid Ref TQ 078 444
The village of Ecclesden declined to a couple of farms in the eighteenth century. It was situated around a green near Ecclesden Farm or manor in the Middle Ages. There are earthworks in a field south of Ecclesden manor and bumps to the west. There are also vague bumps in a field west of Cow Lane and a few bricks in the lane may have come from a building on the site. Ecclesden manor is reputed to have once been a monastery.

Egdean

OS Grid Ref SU 997 202
The desertion of Egdean, or Bleatham as it is sometimes known, is thought to be due to the Black Death. The village once had shops, houses and a pub. The pub is now Church House and the north end of the house is timber framed and sixteenth-century origin. There are vague bumps in a field east of the church, which could be the site of the village.

Endlewick

OS Grid Ref TQ 541 065
Earthworks of a possible DMV were reported at Endlewick, but the area has since been ploughed and the earthworks no longer exist. There are some slight irregularities east of Chilver Bridge and vague bumps just north of Endlewick Farm. However, there is no documentary evidence to show that Endlewick was once a village or hamlet rather than a manor.

Exceat

OS Grid Ref TV 523 988
The village of Exceat was deserted at the time of the Black Death or bubonic plague and was also attacked by French raids. By 1460 only two houses were left standing and the church was in ruins. The foundations of the church can still be seen and there are slight disturbances in fields west of the church., although the area has been ploughed. A stone marks the site of the church today and has an inscription about it.

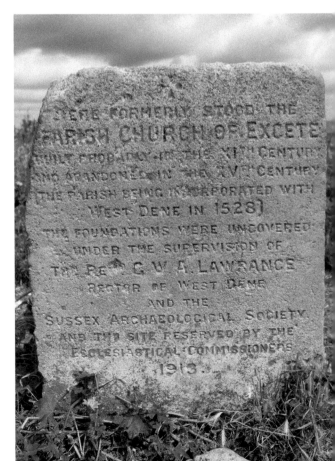

Stone marking site of the church, Exceat.

The village once stood in the fields around the church, Ford.

Ford

OS Grid Ref TQ 002 037

The desertion of the village is thought to have been due to the Black Death in the fourteenth century. Earthworks on the site appear to consist of much disturbed house platforms in fields around the area of the church. These earthworks were cut through by the construction of the Portsmouth & Arundel Canal in 1818. During its construction considerable foundations of buildings were discovered.

Glatting

OS Grid Ref SU 972 142

The lost village of Glatting is near Sutton and the period of its desertion is unknown, but was probably during the Middle Ages. On the site today is a farm and there are no visible earthworks to be seen of the former village.

Greatham

OS Grid Ref TQ 032 159

The grid reference given is that of the possible site of Greatham village, where there are hollow ways, house platforms and disturbed ground in the vicinity of Quell and Glebe farms. Medieval pottery and Saxo-Norman wares have been found on the site. It is not known why the site is so far from the church, which is around a quarter of a mile to the east.

It is possible that the village was originally around the church (vague bumps in a field suggest this) and was shifted to the west near the River Arun at a later date. The village around the church was probably deserted at the time of the Black Death and the village near the river sometime later.

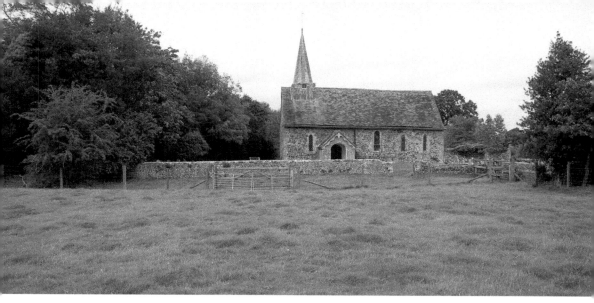

Site of houses and street near the church, Greatham.

Ham

OS Grid Ref TQ 058 038

The medieval village of Ham, around a mile south-west of Angmering, was deserted sometime in the Middle Ages. There are slight humps in woodland south of the eleventh-century Ham Manor, which may represent the site of former houses. A few old houses still exist on the site today, one of which was once an old coach house.

Site of the village near Ham Manor, Ham.

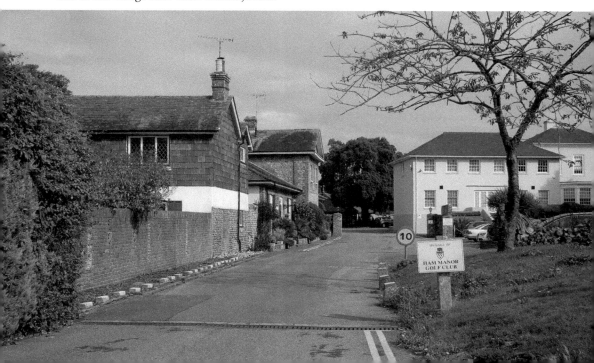

A typical deserted medieval village where the church stands by itself, Hamsey.

Hamsey

OS Grid Ref TQ 414 122

Hamsey village, which was the ham of the de Say family, was deserted at some uncertain date, although it could have been during the Black Death according to local tradition. Today there are no visible remains of the lost village apart from slight disturbances to the south and west of the church where medieval pottery, a chimney pot and quern fragments were found. Outlines of house foundations can still be seen in dry weather by crop discolouration.

Hangleton

OS Grid Ref TQ 268 074

The village of Hangleton, north-west of Brighton, was deserted sometime in the Middle Ages. It was situated on an ancient trackway north-east of the eleventh-century church. The trackway is believed to date from the early Iron Age and was still in use as a highway in 1635. It no longer exists north of the church. South of the church is a long green called 'Hangleton Park' and it is said that victims of the Black Death were buried here.

Excavations were carried out at Hangleton in the 1950s before the site was built on by the growth of Brighton and Hove. Long houses dating to the thirteenth century were revealed. Mounds and hollows were also excavated. The long houses were found to have two living rooms and a cross passage, which separated a third room, which was used for some farming purpose. One of these is reconstructed at the Singleton Open Air Museum.

Lost village and green where plague victims are said to be buried, Hangleton.

Hastings Parishes

OS Grid ref *c.* TQ 800 090

There were seven parishes in Hastings, known as St Andrew-sub-Castro, St Clement, St Leonard's, St Margaret, St Mary Magdalen, St Michael, and St Peter. These parishes were lost either to the sea by coastal erosion or depopulation. The depopulated parishes were resettled in the nineteenth century and St Leonard's was built as a new town in 1828. St Leonard's had a free chapel in 1458 and it survived after the parish was depopulated.

Old St Clement's Church in the sea and the existing one, Hastings parishes.

Hastings is one of the Cinque Ports and had a harbour, which began to silt up in the early fourteenth century. There is a timber-framed building in All Saints Street. St Peter, which was mentioned in 1428, was probably lost to the sea by 1440. At the extreme south-west edge of the east cliff human skeletons and fragments of a building were discovered, which were thought to be the remains of St Peter's Church. Foundations of a round tower were also found. St Michael was mainly submerged by the sea in the fourteenth and fourteenth centuries. On the cliff known as Cuckoo Hill the church was built; its foundations were identified in 1834.

The oldest churches in Hastings are St Clement and All Saints. The old church of St Clement fell victim to the sea and a new one was erected in 1286 further inland, which was destroyed by French raids in 1378. A new building was erected in 1380. All Saints Church was built around 1436.

Heene

OS Grid Ref TQ 138 027
The village of Heene suffered much coastal erosion over the centuries, but the date of the desertion of the village is uncertain. Today there are a few traces of the old village, including the stone walls of Croft Cottage. Chapel Croft had for many

Ruins of thirteenth-century church with a fourteenth-century font, Heene.

centuries been the name of a plot of ground north of the church and the site is now occupied by houses known as 'Chappell Croft'. The site of the old village is now built over by the growth of Worthing.

Early in the eighteenth century, the thirteenth-century chapel at Heene fell into disuse. The first church was Saxon and it is in doubt whether it was on the site of the thirteenth-century building and there is a theory that it may have been sited south of the village and destroyed by coastal erosion. This means that the original Saxon village would also be under the sea. The new church was built on the site of the old chapel in 1873. The ruins of the latter stand at the east end of the new church. It contains a fourteenth-century font.

Heighton St Clare

OS Grid Ref TQ 478 075
The alternative name for Heighton St Clare was East Firle and the site of the lost village is in Firle Park. There are several irregular mounds on the site and a silted pond. The manor house was abandoned before 1496 and the settlement was deserted sometime between 1450 and 1600. The nearest settlement to Heighton St Clare is that of Heighton Street where there is a group of houses.

Hove

OS Grid Ref TQ 286 048
Today Hove is a large town, but was once a deserted medieval village. Very little is known of Hove before 1014 when a heavy sea inundated a large part of it and a great area was permanently flooded and 150 acres were submerged by the sea between 1260 and 1340. Hove also suffered severely from a French invasion in the sixteenth century when Henry VIII made himself master of Boulogne and the French king retaliated by dispatching a fleet of 226 ships carrying 60,000 men to devastate the south coast of England.

People went to live in many Downland villages, leaving a small and poor community to live in Hove. The old church, which was the town's greatest glory, was a ruin, but the inhabitants love for it lived on. They were unable to rebuild the south aisle and probably would not have had the congregation if they did. The aisles were bricked up and the tower fell into further ruin. By 1700 Hove was a ruinous village until the founding of a new town in the nineteenth century. The old village existed along the present Hove Street.

The church is of Saxon origin and was built in the eleventh century. It was constructed with black flint and Caen stone. There was a partial restoration of the church in the eighteenth century and was completely restored in 1836. The only old part of the church is the nave interior and the pillars. During the building of a new tower, a Norman tombstone was found.

Hydneye

OS Grid Ref TQ 609 028

Hydneye (pronounced hid-nye) was a port attached to Hastings, but it is uncertain when it ceased to be a port. The desertion of Hydneye is also uncertain. There was probably a small harbour at Hydneye, which silted up in medieval times. Fields in the area were found to be uneven and when a part of a field was drained in the nineteenth century, foundations of walls were seen. Fragments of medieval pottery were found on the site.

 In the early 1930s the site was described as a rise of grassy land, bare and lonely. The site was built on by 1940 due to the growth of Hampden Park, but a section of it is still left with slight humps north of the houses in Midhurst Road. The first edition of the 6-inch OS map (1879–80) shows a road system with a circular mound nearby.

Iham

OS Grid Ref TQ 902 174

Iham was a small port and in a rental of 1291 it paid an annual rent of 4,000 red herrings to the abbey of Fecamp. The fate of the village is uncertain, but was probably deserted when New Winchelsea shrank in size (see part 3) in the fourteenth century. Iham once had a parish church dating to the Saxon period and was abandoned by 1500. On the site today are a number of earthworks in the form of bumps and hollow ways representing streets and house sites. Winchelsea windmill was built on the site of Iham's church in the early part of the eighteenth century. This is now a ruin after the great hurricane of 1987.

Remains of Winchelsea Windmill on site of the Saxon church, Iham.

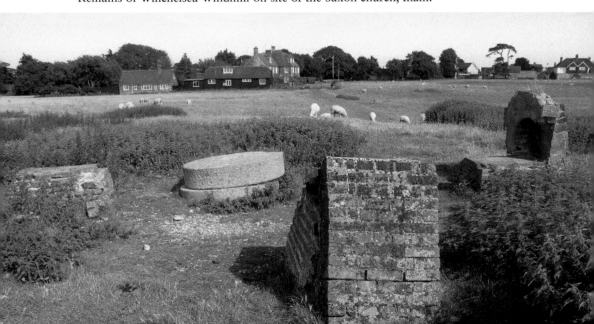

Islesham

OS Grid Ref TQ 008 018

The village and chapel of Islesham or Illsham as it is sometimes called was originally thought to have been lost to sea by coastal erosion and some 600 yards out near the lost village of Atherington. Islesham village is now thought to be inland in the area around Kent's Farm around a quarter of a mile south of Climping church. On John Speed's map of 1610 and also John Blaeu's map of 1645 Islesham is north-east of Bailiffscourt. Islesham was deserted in the Middle Ages and there are only a few humps and bumps in fields on the site today in the area of Kent's Farm.

The site of Islesham chapel is uncertain, but there are three possible sites for it. One of them is where Climping's St Mary's Church of England School now stands, another site to the east of Kent's Farm and the third being south of the farm. Another possible site could be in a field north of Kent's Farm where there is a slight mound.

Bread Lane (now a footpath) went southwards towards Atherington from the school and there is a field south of the school known as 'Holybreadths', which gave it its name. Holybreadths is probably land that was charged with the payment for holy bread and is referred to in the rubics at the end of the communion service of the 1549 prayer book. Was this field adjacent to the chapel?

Itford

OS Grid Ref TQ 434 055

The desertion of the village was probably due to the Black Death, and it was only a farm by the sixteenth century. On the site today are Itford Farm, Kingston Cottages and there are irregularities in a field west of the cottages and earthworks

Earthworks of former medieval village, Itford.

in a field south-west of the farmhouse, which may well be the sites of houses. The village of Itford had common fields in the fourteenth century. Parts of Itford farmhouse was a monks rest house before the tenth century.

Kingston

OS Grid Ref *c*. TQ 085 013

The village of Kingston and its chapel was lost to the sea due to coastal erosion in the seventeenth century. The chapel is shown on Saxton's map of 1575, the Spanish Armada map of 1587, on Hondius' map of 1610 and on a map of 1669, but not on a map dated 1770. There is very little information about Kingston chapel, which was a thirteenth-century building, but could date back to the mid-twelfth century. It was rectangular with a roof made of Horsham stone.

A Kingston church warden, 'Robert Baker', made a premonition in 1626, which said, 'The chappell is much decayed by reason of the sea'. A vicar of Ferring records that the last service in the chapel took place when the waves were washing up the sides of the chapel walls, which were surrounded at high tide. The chapel itself is said to have disappeared by 1641.

At low tides some black rocks around half a mile out are uncovered and it is said that they are the ruins of the old chapel. It is also said that the bells can be heard ringing at certain times of the year. Archaeologists excavated a well nearby and only the bottom foot was all that remained. This means that at least 15 feet of the original coast was eroded when the sea encroached and any building, such as a chapel, would have crumbled away and vanished.

Kingston manor dates from the eleventh century and lies well inland, and Lighthouse Cottage is in Sea Lane. This lane leads out to the sea and disappears. Further west is Peak Lane, which was originally Kingston Street, which also goes out to the sea, becoming a path and then a hollow way on the Greenward Way. Both Sea and Peak Lanes led out to the chapel.

Village and church lost to the sea by coastal erosion, Kingston near Ferring.

The Greensward Way was once cattle grazing fields. There are humps and bumps along Peak Lane, which represent house platforms of the former village of Kingston, and there are foundations of buildings on the east side of the hollow way.

Kingston Buci

OS Grid Ref TQ 236 053
This village was larger in medieval times than it was in the eighteenth century. It is uncertain whether its decline was due to desertion of the village around the Saxon church or the erosion of land on which another group of houses stood further south. It is said that some houses belonging to the manor had fallen down and were washed into the sea.

The only houses in the village are the manor house and rectory. During the nineteenth century building took place and in the twentieth century Kingston Buci was residentially and commercially an extension of Shoreham. The village was originally named Kingston and known as South Kingston by the late fourteenth century. It is now known as Kingston Buci.

La Holt

OS Grid Ref TQ 105 062
La Holt was a thriving hamlet in the Middle Ages and there were twenty-one landowners there in the thirteenth and fourteenth centuries. It is said that the Black Death wiped out the inhabitants and the village was deserted. The only remains of the village today are two cottages called Wood Cottage and Keepers Cottage. The latter is reputed to have been an inn that served the village.

Site of old village with two cottages still remaining, La Holt.

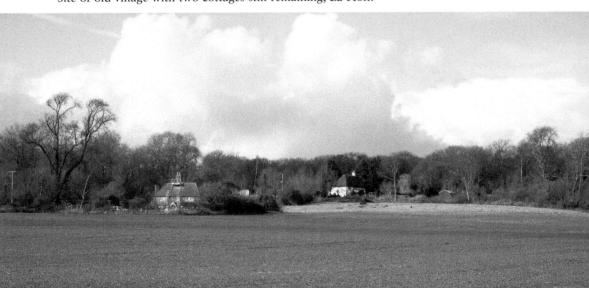

The field south of the cottages to the east of the footpath has been ploughed and there are no signs of the village to be seen in it. There are slight bumps and possible house platforms in a field to the north of Keepers Cottage, also east of the footpath, which could represent sites of houses. The footpath going westwards is a medieval path that took the inhabitants of La Holt to Clapham church.

Linch

OS Grid Ref SU 849 185
There were two parts to Linch parish, of which the main settlement was around the church and the other part lay 7 miles to the north around Woodmansgreen. The desertion of the village took place in the Middle Ages and there is a reference to Lynche in the parish of Bepton in 1550. There is nothing to be seen of the village today; only flat grass and Linch Farm now occupies the site.

The church, which was mentioned in 1086, stood in the present stackyard of Linch Farm. No trace of it is visible above ground today. A quantity of human bones and a medieval stone coffin were found on the site during the eighteenth and nineteenth centuries. A chapel of ease was built at Woodmansgreen in the sixteenth century, which was in ruins by 1635 and rebuilt in 1700. It is marked on John Speed's map of 1610 as 'St Luke's Chapel'.

Lordington

OS Grid Ref SU 782 098
Lordington was known as Harditone in 1086 and had a watermill. Lordington was once a separate parish and village with a chapel. It has been united with Racton since 1440. The village was deserted sometime around 1350 during the Black Death. On the site today are a number of lynchets and house platforms. Quantities of pottery and roofing tile were seen in rabbit scrapes. There is no trace to be seen of the chapel today. Lordington House, built in 1505, still stands today.

Lower Barpham

OS Grid Ref TQ 071 092
The deserted medieval village at Lower Barpham lies west of Lower Barpham Farm. The field is very disturbed and in use as a hay meadow. The desertion of the village is uncertain, but was probably at the same time as nearby Bargham. There are earthworks on the site and there is an east to west street with several small enclosures along either side. At the south-west end of the village is a larger enclosure and this is probably the site of a manor house.

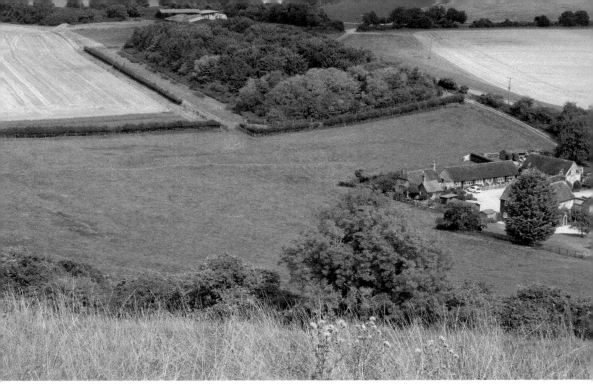

Earthworks of old village and site of the main street, Lower Barpham.

The street is bordered by earthen banks and all enclosures are separated by lynchet-like slopes. No traces of foundations are visible on the site. The earthworks are seen from the footpath along the top of the adjacent hill. The farmhouse and outbuildings date to the nineteenth century.

Lowfield Heath

OS Grid Ref TQ 274 402

This village was originally in Surrey and moved into Sussex together with Gatwick Airport. The village was pulled down in 1978 for commercial purposes and only the church was left. There were old cottages, a village hall, a blacksmith's, a school and a pub known as the White Lion. On the site today besides the church are modern factories and a Travelodge, which was originally the Gatwick Concorde Hotel.

There was also a public house called The Rounds, which is no longer here. The latter was on the site of a seventeenth-century inn called Halfway House because it was halfway between London and Brighton. Old Brighton Road, which ends by Gatwick Airport's runway, was the old London to Brighton road. The church dedicated to St Michael and All Angels was built in 1867 in the thirteenth-century style.

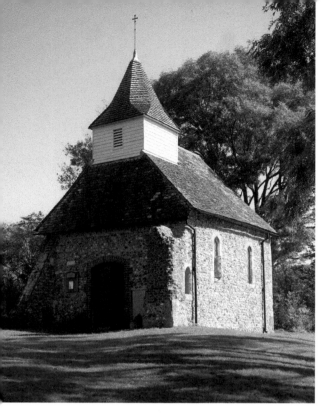

The small church said to be the smallest in England, Lullington.

Lullington

OS Grid Ref TQ 528 031

Lullington, near Alfriston, was destroyed in 1349 by the Black Death. It is believed that there may have been houses in the vicinity of the church, but there are no identified earthworks remaining on the site today. There is a lost road that runs from the footbridge over the River Cuckmere at Alfriston, going past the church at Lullington parallel with a footpath.

The church is only 16 feet square and claimed to be the smallest church in England. It is only the chancel of a larger church, which was damaged by fire in the seventeenth century by Oliver Cromwell. The nave was ruined and fragments of it can still be seen today. Excavations were carried out at the church from April 1965 to July 1966. During excavations roofing tiles, pottery, glass, graves and other items were found. One grave was that of an infant.

Manxey

OS Grid Ref TQ 652 071

The medieval village of Manxey, on the Pevensey Levels, was probably lost either due to the plague or storms in the fourteenth century. It had a chapel, several

houses and a moat with enclosures. The moat is shown on Budgeon's map of 1724 as 'Pound' and is situated in a field called 'Pound Field'. The village was situated on a raised area east of the Pevensey to Wartling road.

On the site today are earthworks of the old village including the moat, which is well preserved. There was also a pond on the site. Some 200 yards to the south-west of the moat is the site of Manxey chapel. It was probably built in the thirteenth century. The site is represented by a raised platform in a field called Church Acre. The chapel probably came out of use when the village was deserted.

Middleton

OS Grid Ref *c*. SZ 975 997
The history of Middleton goes back to Anglo-Saxon times and it is mentioned in the Domesday Book as Middeltone. A church existed at Middleton before 1066 and the village was a flourishing community and an important fishing centre. The village was slowly being washed away into the sea during the seventeenth and eighteenth centuries and in 1724 the south aisle of the church was only 60 feet from the high tide mark. The tower and most of the chancel fell by the end of the eighteenth century. There was a disastrous gale in 1830.

The church by 1795 stood dangerously on the edge of a low cliff and in 1837 there was a burial put into the register (this being the last entry) and not long after this, the church fell victim to the encroaching sea. This church, dedicated to St Nicholas, was a thirteenth-century building that was probably built on foundations of the original Saxon one. The church stood on the west side of Sea Lane, which goes out to the shore. Nothing can be seen of the church and village at low tide today.

The only remains from the old church are the register dating from 1560 and an Elizabethan chalice and paten dated 1576, which are now in the new church at Middleton (built in 1849). In the churchyard are some eighteenth-century tombstones, which were washed up on the beach, that came from the old church. One of the graves is dated 1775.

Eighteenth-century graves from the old church now in the new one, Middleton.

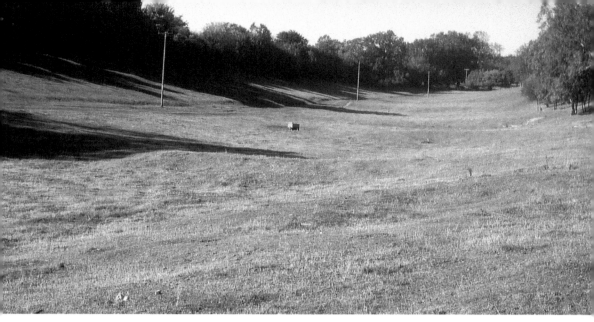

Earthworks of the deserted medieval village, Monkton.

Monkton

OS Grid Ref SU 829 165
The village or hamlet of Monkton was deserted sometime before 1608. The site lies some 2 miles north of Chilgrove. The site of Monkton in the seventeenth century only had a farm or large house and was known as Northolt, Munckon, Monking or Muncton. On an estate map of 1623 the name Winden is marked and the site may have been known in the fourteenth century as Winden. This name survives today as Winden Wood, to the east of the deserted site.

Earthworks are to be seen on the site today and there is evidence of some twelve or more possible house sites with tofts and crofts visible as depressions and banks. The main route through the site is marked by a double lynchet trackway. There is a dry pond, well and remains of a donkey wheel on the site and also the ruins of Monkton Farm. Documentary evidence and the existing earthworks indicate that it was once the site of a village or hamlet.

In some of the wooded areas around there are lynchets and field banks, suggesting that they were once cultivated fields. The village or hamlet and Chilgrove chapel were possibly situated on a downland route from West Dean to Treyford and can still be traced over the Downs. The chapel was sited between Chilgrove and Monkton and probably served both places.

The site of the chapel was excavated in 1977. It consisted of a rectangular nave and apsidal chancel, and dates from the twelfth century, but could be earlier. It was taken down in the seventeenth century and a map of 1797 shows a field called 'The Chapel'. Pottery was found, some dating from Saxon times. The site is now overgrown and in woodland.

Muntham/Cobden

OS Grid Ref TQ 105 103

The name of the village is uncertain as its site lies between Muntham and Cobden Farms and so it is called Muntham/Cobden or Muntham (or Cobden). The desertion of the village is also uncertain and the site lies in a valley. There are good earthworks on the site, as is shown on aerial photographs, but the site has been ploughed in the past. The site is now used for grazing.

A vast quantity of medieval pottery was found on the site of the lost village, most of which dates from the thirteenth century. Concentrations of large flints were also found there. When the site was ploughed there are some irregularities in the fields and also earthmarks representing the old village.

Myrtle Grove

OS Grid Ref TQ 094 082

Myrtle Grove lies around 1.25 miles north of Clapham and its desertion was probably due to the Black Death in the mid-fourteenth century. On the site today are several earthworks of the deserted village in a field east of Myrtle Grove Farm. A spread of medieval pottery was found on the site in 1970. There is a hollow way and slight irregularities visible today. Also on the site are two lynchets and a mound.

Newtimber

OS Grid Ref TQ 271 134

The village of Newtimber was deserted owing to the plague between 1603 and 1621, and the church was in a bad state of repair in 1586. Today there are no visible earthworks to be seen of the old village apart from vague bumps. All that remains of Newtimber is a restored thirteenth-century church and rectory, standing by themselves south of the sixteenth-century Newtimber Place.

Northeye

OS Grid Ref TQ 683 072

Northeye was one of the limbs of the Cinque Port town of Hastings and was an important seaport. The town was probably destroyed by great storms in the thirteenth century and was submerged. There were a number of eyes or islands around the Pevensey Marshes. The site of Northeye is today known as 'Town Field' and the first chapel stood on the height of Hill Farm.

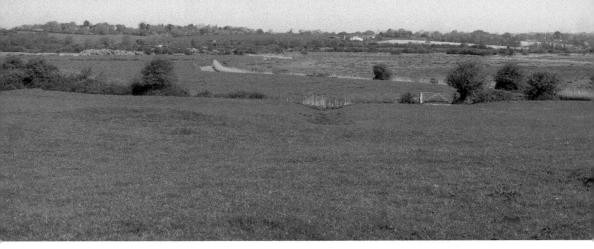

Earthworks of a once busy village, Northeye.

A second chapel was erected at Northeye in 1262 and a new town built in the fourteenth century around half a mile south of the old one after the land was reclaimed and drained. This new town was probably deserted by 1400 and the site today is called Chapel Field. It is not known when Northeye ceased to be a port because Hastings Corporation lost all of its records in the sixteenth century.

The chapel was founded by William de Northeye and probably continued to be in use until the sixteenth century. The chapel ruins were marked on seventeenth- and eighteenth-century maps and existed until the mid-nineteenth century when they were used for road building. On the site of Northeye today, on both Town and Chapel Fields, are good earthworks and roads. Other than this there are confused earthworks, which mark the site of the village.

In 1857 the grass had to a considerable extent perished in lines as if over foundations of buildings that stood there. There was a dry summer in 1859 and the shape and size of the chapel could be defined. Northeye chapel consisted of a nave, chancel and small tower as far as its foundation walls have been traced. Also a considerable village or town was able to be discovered.

In the dry summers of 1938 and 1952 outlines of foundations were visible. In 1952 excavations were carried out on the site and foundations of a building were uncovered. Pottery dating between the fifteenth and sixteenth centuries and slates were found, the slates being grey and grey-black in colour.

North Marden

OS Grid Ref SU 808 162
The Mardens are four villages and are East, North, West and Up. They are around 10 miles north of Chichester. Two of the Mardens (North and Up) are deserted (see later for Up Marden). The date of the desertion of North Marden is uncertain and there is disturbed ground, banks and mounds north and west of the church. Today there is only a farm and church at North Marden. On the road to East Marden is a 300-year-old house called Gobbersfield, which was once a post office.

Remains of Norman chapel,
Old Erringham.

Old Erringham

OS Grid Ref TQ 205 077
Old Erringham is around 2 miles north of Shoreham and the road to it from the
A283 leads to Erringham Shaw, where trees grow on the steep sides. These steep
sides are ancient river cliffs of the Adur Estuary. The desertion of Old Erringham
village is uncertain and there are vague bumps on the site today making no certain
pattern. There is a house, farm and remains of a Norman chapel at Old Erringham.
A sunken weaving hut and graves were found on the site during excavations.

Ore

OS Grid Ref TQ 836 114
The village of Ore was probably deserted at the time of the Black Death and in
1361 the manor house was in a bad state of repair and there were few tenants
on the land. The greater part of the parish was added to Hastings by the local
Government Act of 1897. Ore Place is a stone building built in 1864, now a
Roman Catholic college, and north of this are the ruins of the former house.

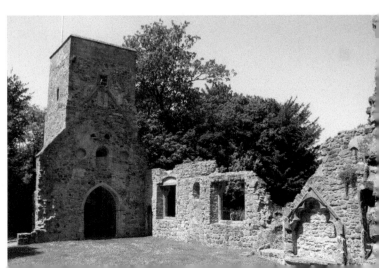

Old St Helen's Church in
ruins, Ore.

The twelfth-century church, dedicated to St Helen, is now in ruins. The tower, north part of the nave, north and east part of the chancel still remain. The new church on the B2093 also dedicated to St Helen was built in 1839 and contains a brass from the late fourteenth century of an unknown couple, which came from the old church.

Pangdean

OS Grid Ref TQ 294 117

Pangdean was mentioned in the Domesday Book as Pinhedene and the charters of around 1140 and 1147 refer to the church at Pangdean. There is no sign of this church or the village remaining today and Pangdean Farm occupies the site. There are medieval fields in the vicinity of the farm.

It is said that the plague, which destroyed nearby Pyecombe in 1603, made a farmer of Pangdean live in a cave at Waydown near the village to escape the plague. After returning some weeks later, he was the last to die from the disease. Pangdean was probably lost due to this plague. The site is now ploughed.

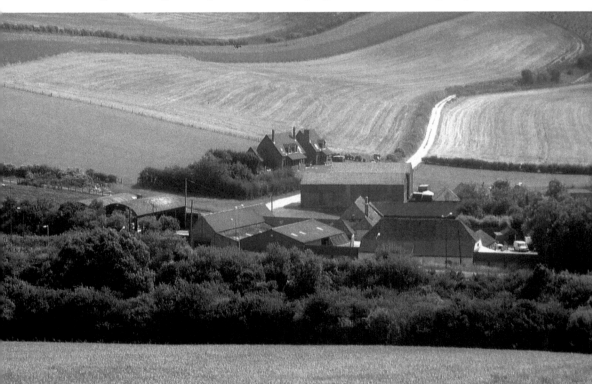

Farm on site of church and village, Pangdean.

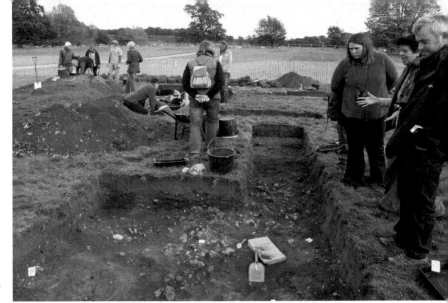

Excavations at lost village site in 2009, Parham.

Parham

OS Grid Ref TQ 059 141

The desertion of Parham village is unknown, but its remains were pulled down in 1778–79, leaving the church and a Tudor house. No visible remains of the village can be seen today in the area around the church where it once stood. When a ha-ha fence was being built in 1971 in the grounds of Parham House signs of the village were discovered. The results revealed evidence of a thriving community reflected in the type and quantity of pottery found, dating to the twelfth and thirteenth centuries. It is possible that Parham village dates from the Saxon period. Recent excavations were carried out on the site to locate the site of the village.

Parham church dates from around the twelfth century, but was largely rebuilt in the early part of the nineteenth century. There are several things of interest in the church including a private pew, which has its own fireplace. The church has a fourteenth-century leaden font, which is one of three in Sussex. The others are at Edburton and Pyecombe.

Parrock

OS Grid Ref TQ 447 347

Parrock was known as Apedoc in 1086 and Paddockrowe in the late thirteenth century. The name means a small enclosure or paddock. Parrock lies between Forest Row and Hartfield. A scatter of pottery has been found dating between the thirteenth to sixteenth centuries, which documentary evidence suggests that Parrock may be a deserted medieval village. Parrockrowe refers to row of houses built there at that time. There is no sign to be seen of the village today.

Pende

OS Grid Ref *c*. TQ 189 036
The lost thirteenth-century port of Pende was mentioned in 1250 and was a recognised port with officials from then until the end of the fourteenth century. The name Pende is from the Old English 'Pynd', which means enclosure. It describes the partially enclosed harbour. It is thought that the mouth of the Arun was here in the thirteenth century, but storms late in the same century and a rise in sea level opened a new mouth for the river between Rustington and Littlehampton.

There is mention of sea walls at 'La Pende' in 1351, which were probably defences, and in 1359 a commission was set up to repair some of them. Victuals were loaded in a ship at Pende in 1382 and in 1399 a vessel was being built but was seized before construction because wood was taken without obtaining the king's licence. Other boats were probably loaded and unloaded at Pende.

The last reference so far found of Pende was in 1420 when a ship sailed from Pende to Rouen, carrying provisions such as wheat with English forces then stationed in France. By the mid-fifteenth century, the sea overwhelmed the port of Pende. Also documentary evidence shows that the Ferring and Teville streams could not keep the port open and so it must have silted up.

The name Pende still exists today in Penhill Road in Lancing, which was to the north of the site. The area to the east of Penhill Road was once known as Pende Hill and was the hill overlooking the port. There may have once been houses on this hill in medieval times and perhaps a small chapel. It is now built over by modern housing. It is possible that the village of Pende, which served the port and possibly a church, may have been further eastwards on a site now under the sea opposite the Church of the Good Shepard, Shoreham Beach.

There are rocks in the sea (particularly Church Rock) that are said to be the remains of the village and church. These rocks are never uncovered at low tide, but according to a Nautical map of 1844, the very tops of them were just visible at very low spring tides. This means that the rocks have eroded and the sea level had risen since then. It is also said that Church Rock was so named because it was a quarry where stone was quarried to build the churches in Shoreham and perhaps at Pende.

Site of medieval port and village now in the sea, Pende.

A lagoon behind the beach was marked on the Armada map of 1587 as 'Penhowse', which is now the Shopsdam Road area and possibly the site of Pende. The name Shopsdam derived from 'Lancing Shoppsdam' or 'The Damm', which was a dam that led across the water to the shopps in the seventeenth and eighteenth centuries. The shopps were fishermen's huts. This and the old port of Pende are now in the sea and very little is seen at low tide.

Peppering

OS Grid Ref TQ 036 093
The desertion of the village of Peppering near Burpham is uncertain, but it could well be due to the Black Death. There are earthworks in a field to the west of Peppering Farm and also some irregularities. Medieval pottery was found on the site. Today there is a farm, a few cottages and Peppering House on the site.

Further west of the site are the ruins of a cottage. A popular silent film called *Tansy*, based on a novel by Tickner Edwardes, was filmed on location between Amberley and Burpham. The ruined cottage was in good repair at the time and used as the home of the main character in the story. North of Peppering is the site of a moat that surrounded a medieval settlement.

Perching

OS Grid Ref TQ 242 115
This deserted medieval village consists of small platforms where medieval pottery was found. There are no earthworks of precise identification visible today, only various bumps. Ploughing has obliterated other earthworks and Manor Farm is

Earthworks of lost village behind Perchinghill Barn, Perching.

the only building on the site still standing today. The village of Perching once had a chapel, which no longer exists above ground.

The medieval manor house or castle of Perching stood around 300 yards west of the existing farmhouse and the site is today marked by a large square mound with traces of a moat faintly visible. The remaining earthworks indicate that Perching castle was more likely a fortified manor. The date of the desertion of the village is uncertain, but could be due to the plague of the fourteenth century.

Plumpton

OS Grid Ref TQ 356 135
The village of Plumpton was probably deserted at the time of the bubonic plague in the mid-fourteenth century. There are earthworks in fields north and south of the church, which show where the village once stood. The footpath going to the church may have once been the main village street. There are also slight earthworks in a field further east towards the Half Moon pub.

The church, dedicated to St Michael, dates from the early twelfth century. It was built on the site of a Saxon church mentioned in the Domesday Book. On the north wall of the nave are some medieval wall paintings and the font with a square bowl dated 1710 stands on a twelfth- or thirteenth-century base.

Cottages once stood in the area of the church, Plumpton.

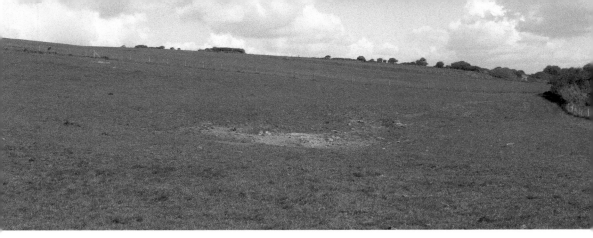

Earthworks of abortive new town of Seaford, Poynings Town.

Poynings Town

OS Grid Ref TV 508 985

Seaford once had a harbour and a port, which have long since disappeared when the River Ouse was directed and straightened to enter the sea at Meeching village, which is now called Newhaven. Seaford also declined due to French attacks, fire and pestilence. During the proprietorship of the port of Seaford by the Poynings family, an attempt was made to found a new town of Seaford on a commanding portion of the South Downs 2 miles to the east overlooking the Cuckmere Valley.

This new town was started and was aborted after French raids and fire either during construction or after completion and was short lived. In the nineteenth century remains of various houses and other earthworks were traceable on the site. The foundations extending to some 20 acres were visible as irregularities and the site was examined. The earthworks were considerable in the nineteenth century and showed that a sizeable settlement existed there, but by the 1970s there were only a few house platforms visible and these are threatened by ploughing.

These earthworks were probably those of the deserted medieval village of Chinting as mentioned earlier in the book and there is very little documentary evidence of the abortive new town of Seaford called Poynings Town. There are still traces of buildings on the site today and Seaford, which was mainly burnt down as recorded in 1556, recovered on its original site.

Racton

OS Grid Ref SU 780 092

The village of Racton is around 3 miles north of Emsworth and was deserted in the Middle Ages. Today there is a twelfth-century church, cottages and a farm at Racton. There are ill-defined earthworks on the site and house platforms. There are also crofts, but the church is more than 300 yards from the nearest

Church and cottage said to be where Charles II stayed, Racton.

croft. A scatter of pottery from the twelfth and thirteenth century was found in one of them. This suggests that the main part of the village was near the church, but the site was destroyed when Racton House was built.

On the north side of the B2146, rubble in fields represent the site of Racton House, which was a manor house, said to date from the early fifteenth century and demolished in 1841. A village pump stands on the site of Racton House. The old house next to the church is said to be where King Charles II stayed during his escape from Worcester in 1651.

Shelley

OS Grid Ref TQ 250 313
Shelley, around 3 miles south of Crawley, was once an ancient parish with a church and rectory. The name Shelley was spelt as Sulfleg in 1279 (from 'scylf leah', meaning 'the shelf clearing'). This donates a cleared area of woodland on the narrow strip of land in the area, which fell away on either side to valleys. It was known as Shelfegh in 1317.

The church was mentioned in 1291, 1407, 1478 and it became a chapel in around 1510. It was in use until 1585. By 1341 half of the parish was emparked as Shelley Park and then disemparked in Elizabethan times. The area today is known as Shelley Plain and Shelley Farm is half a mile to the north. No trace of the village can be seen today.

In 1898 the site of the church was thought to have been located when sandstone foundations were dug up. Further digging in 1954 produced nothing on the presumed site of the church, but in 1962 excavations were carried out further south and foundations of a stone building were discovered but could not be dated. It was suggested to be seventeenth or eighteenth century in date and therefore unlikely to be the church. The area excavated was called Chapel Field. The village was probably deserted in the Middle Ages.

Shermanbury

OS Grid Ref TQ 215 188

Shermanbury is a possible DMV and on the site today are a Norman church, Shermanbury Place and a couple of houses. There are a few irregularities in adjacent fields. A long lane reaches the church and site from the main A281 north of Henfield, which may have once been the main route to the village. There is a farm to the south-west of the church.

Southerham

OS Grid Ref TQ 427 094

Southerham was probably a hamlet, which had a chapel and cottages, but is only a farm today. The chapel dedicated to St Mary was converted into a cottage, but was destroyed in the nineteenth century and there are no remains of it today.

Southerham House in Southerham Lane.

A skeleton was found embedded in the north wall. On the site today is Southerham House and a farm with old barns converted into homes. There are vague bumps on the site and the date of desertion is uncertain.

Sutton

OS Grid Ref TV 494 997

Sutton, near Seaford, was deserted towards the end of the fourteenth century or early in the fifteenth century. The church, which dates from the twelfth century, was still in existence in 1585 and in 1589 Sutton survived as a farm. The place has been resettled since 1918 due to the growth of Seaford and now the site of the lost village is largely built upon. In 1260 a religious hospital was founded at Sutton, which was dedicated to St James and no longer exists. Sutton Place dates from the sixteenth century.

The church no longer exists and was roofless in the sixteenth century. Its condition was too bad to restore and was in ruins by the nineteenth century. The site is in the grounds of Sutton Place and in the 1940s human remains from the twelfth century were found, one being a child. Further digging revealed church foundations and its plan measured around 90 feet by 40 feet. The church consisted of a nave, chancel, south and north aisles. It also may have had a tower.

Tide Mills

OS Grid Ref TQ 459 003

In 1761 a tide mill was erected to grind corn or grain east of Newhaven. The mill was operated by a reservoir, which was formed by damming the creek and fitting it with sluices. Large areas of marshland were drained and earthen banks constructed. Cottages, a blacksmith's, carpenter's shops, mill offices and a granary were provided for a village population of around 100. A windmill was built on top of the granary and there was a large barn and a small outhouse, which contained a mangle plus another containing coppers for boiling clothes. The windmill was used for hoisting sacks of grain.

Tide Mills developed as a community in the nineteenth century under the influence of William Catt, who had a reputation for hard work. There was a violent flood in 1876 and water poured across the village, flooding it and destroying homes. The village suffered from the sea breaking through in 1912–13 and a number of cottages were destroyed during the First World War. The population was sparse at the end of the war.

After the First World War part of the Tide Mills village was taken over by Dales racing stables, which moved out by the 1930s, and the Chailey Heritage Beach Hospital for crippled children was built, but due to the threat of German invasion

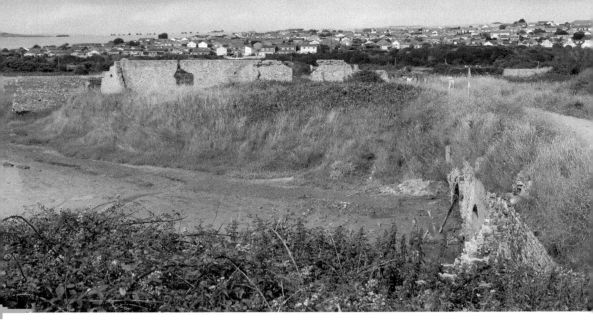

Site of tide mill and remains of village, Tide Mills.

during the Second World War the remaining population was evacuated and this was the end of Tide Mills village. After the Second World War it was in ruins, which still exist to this day. There are plaques at Tide Mills giving details of its history.

Tilton

OS Grid Ref TQ 495 067
Tilton was mentioned in the Domesday Book of 1086 as Telentone and both Battle and Bayham abbeys had land there. The desertion of the hamlet is uncertain, but probably occurred during the Black Death, which was the cause of the extinction of common fields that existed there. There are vague bumps in fields

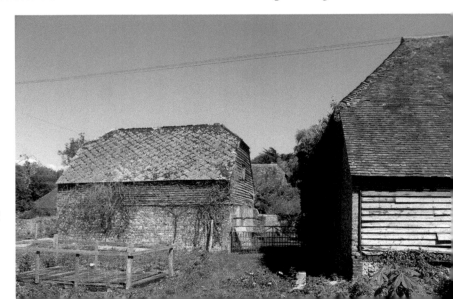

Barns on site of village, Tilton.

north of Tilton House, which may represent the site of the hamlet. A pond and farm buildings exist on the site today and the area is wooded in many places. The present farm buildings were probably built on the site of former houses. The field west of the farm has since been ploughed.

Tortington

OS Grid Ref TQ 003 051
The village of Tortington was probably deserted due to the Black Death in the fourteenth century. It has been accepted as a deserted village by the Medieval Settlement Research Group after the author noticed irregularities and hollow ways in fields north and east of the church. There is a farm and a couple of houses by the church today. The church is Norman and contains a font and brass plate dated 1596.

Tortington Priory, half a mile north of the church, was founded for the Augustinian Canons in the twelfth century. It covered many acres and there are earthworks in a field south of Priory Farm that may well be the site of the priory. Excavations were carried out at the site and several items were found such as tiles, a stone coffin and brick graves. The priory was probably deserted at the Dissolution of the Monasteries. The only remains of the priory are the north wall, which is now the south face of a barn, and a fragment of walling in a field to the east of it.

Earthworks in field near house, Tortington.

Tottingworth

OS Grid Ref TQ 615 219
Tottingworth is around 2 miles east of Heathfield and the village was deserted probably due to the Black Death. It was in existence between 1296 and 1334. There is no trace of the village today and its exact location is not known. The grid reference refers to Tottingworth Farm, which is the most likely site of the village.

Twineham

OS Grid Ref TQ 253 200
Twineham was probably deserted at the time of the Black Death in the fourteenth century. Several footpaths meet here, which were probably roads in the former village. There are humps and bumps around the church and in a field to the west are earthworks. The existing road ends at the church and becomes a footpath, which is raised, showing where the road would have once gone.

The church, dedicated to St Peter, was built of red brick (one of the earliest brick-built churches in Sussex) in the sixteenth century on the site of a thirteenth-century church. There is a thirteenth-century font in the church. In the churchyard by the gate are four stones that mark a late seventeenth-century Quaker burial ground.

Up Marden

OS Grid Ref SU 796 142
The village of Up Marden today only consists of a farm, a couple of houses and a thirteenth-century church. The reason for the desertion of the village is uncertain, but it could have been due to the Black Death. There are only vague bumps on the site today.

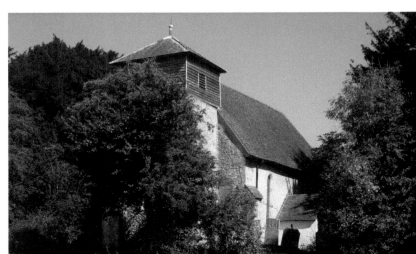

Church standing on its own, Up Marden.

There was probably a church at Up Marden in Saxon times and the tub-shaped font may be more than 1,000 years old. There is a triangular chancel arch in the church, which appears to be Saxon, but there is a rounded thirteenth-century arch above it. It seems that the triangular arch was a later addition to strengthen the thirteenth-century arch. It was originally thought that this triangular arch was from the Saxon church at Up Marden, but it is reputed that the stones of it came from the former church of West Marden.

Wardour

OS Grid Ref SZ 861 978
The grid reference given is the possible site of the medieval new town and port of Wardour, which was mentioned in the thirteenth century and is situated around a mile south-east of Sidlesham. Its foundation may have been an effort to establish a port and harbour on what is Pagham Harbour today. It is uncertain how soon the town failed, but was probably sometime during the plague or French raids in the fourteenth century.

Wardour Green is on a 1755 estate map of Sidlesham and is now known as Rookery Lane. Soil or cropmarks in a field around a quarter of a mile north of Rookery Lane may mark the site of the town. There are flat fields on the site today, and in Rookery Lane are Rookery Farm and a tithe barn. Some slight irregularities are to be seen in a field west of the farm. Further east of this is Halsey's Farm, which is south-east of the site of the harbour. The port was probably to the south of the town in the vicinity of the Crab & Lobster pub.

The southern part of Sidlesham is now a picturesque area with eighteenth-century houses. The Crab & Lobster stands on the site of a tavern recorded since the eleventh century. The bishop probably owned it until Elizabethan times, and refreshments were

Site of abortive town and harbour at Wardour, Sidlesham.

served to travellers and pilgrims. The inn was rebuilt in 1720 and was at first called The Swallow and became the Crab & Lobster in the latter part of the eighteenth century. A tide mill existed at Sidlesham near the harbour. This dates from the Middle Ages and was marked on the Spanish Armada map of 1587. It was demolished during the First World War and only fragments remain today.

Warminghurst

OS Grid Ref TQ 118 169
The village of Warminghurst probably vanished during the Black Death, leaving a late Norman church and a few houses. The manor house, built in the thirteenth century, was west of the church and the High Street mentioned in 1455 and 1524 was likely the north to south road, which separated the manor and church. Crofts on both sides of the road probably represented the site of some six houses. There are no visible remains of the old village to be seen today.

Warningcamp Hill

OS Grid Ref TQ 042 076
There are earthworks of a possible deserted medieval village at the east end of the valley of Woodleighs, which leads to Warningcamp Hill. A field system is visible on the steep hillside and there is an extensive scatter of sherds on the ploughed fields on the north side of the valley on either side of the footpath to Burpham village. Many pieces of quernstone have also been found there.

The name Warmingcamp was named after Waerna, a Saxon chieftain. He established a settlement here in the sixth century. The name of the place was not (according to local legend) a military camp to warn Arundel of impending attack.

West Blatchington

OS Grid Ref TQ 278 068
The village of West Blatchington was deserted sometime around 1428 and the church, which was first mentioned in 1147, was neglected before 1499 and was in ruins by 1686. The ruins of the church are shown on the OS map of 1876. The building development of neighbouring Hove swallowed up the site of the old village and the church at West Blatchington was rebuilt in 1890.

The medieval church originally had a nave and a chancel of the twelfth century, and the ruins of the north and south walls of the nave were used in the rebuilding of the new church. To the west of the nave are lower paves of the walling of a curious annex to the nave. This suggests that the original nave was once longer or part of a tower.

Windmill on site of medieval village, West Blatchington.

The manor house is known as Court Farm and has extensive farm buildings around it. West Blatchington Windmill was built around 1820 on top of the roof of farm buildings. This mill thrashed and winnowed corn as well as grinding it. The mill exists to this day with its sails and is open to the public on Sunday afternoons in the summer months. In the barn is a milling museum.

Wiston

OS Grid Ref TQ 155 124

The desertion of Wiston village is uncertain, but probably was at the time of the Black Death or bubonic plague. There are no earthworks visible today of the old village – only some vague bumps. The footpath at the foot of the South Downs south of Wiston was the main east to west road in medieval times and was known as the Steyning to Washington Road in 1654, remaining the chief road until 1778. It was a shorter route than the modern A283 Steyning to Washington road, which is to the north of Wiston Park.

The only remains of the village today are Wiston House (built in 1576) and outbuildings, a thirteenth century church and a c. seventeenth-century former rectory house. Wiston Park was enlarged between 1795 and 1835 to give the house privacy. The church stands on the site of an earlier church, which was mentioned in the Domesday Book of 1086.

Woodmancote

OS Grid Ref TQ 231 151

Woodmancote, near Henfield, was mentioned in the Domesday Book as 'Odemanscote' where a church and manor are recorded. The name 'Woodmancote' means 'woodman's cottages'. The desertion of the village is uncertain, but could have occurred in the fourteenth century during the plague. There are only a few irregularities on the site today. There is a cutting to the east of the church that may have once been a lane. North of the church is Woodmancote Place.

Wyckham

OS Grid Ref TQ 188 130

Wyckham was a sizeable settlement in the late fourteenth century and probably extended to Huddlestone Farm around 0.75 miles away. The desertion of the village is not certain, but could be due to the Black Death. Wyckham was taxed as a vill in medieval times. Buildings on the site today are Wyckham manor and a nineteenth-century farmhouse called Shelleys. Two brick and timber-framed houses were recorded in 1800 but no longer exist.

There are possible remains of the village in fields to the south-west of Wyckham manor. On the site are a hollow way, field boundary bank and also house platforms on south facing slope between Wyckham manor and Wyckham Farm. Wyckham was known as Wicam in 1073, Wicham in 1225 and Wycham-Juxta-Stenygge in 1307. Wyckham is around 2 miles north-east of Steyning and named from the nearby Roman road, which is an east to west route from Barcombe Mills to Hardham.

Wythering

OS Grid Ref SZ 885 974

The borough of Wythering was south of Pagham village and the town was amerced for a concealment in 1248 and courts were held in 1382 of an early borough. The peak activity in the port occurred in the thirteenth and fourteenth centuries, but it started to decline in the fifteenth century. It was partly destroyed by coastal erosion, but still referred to as a borough in 1456. Wythering has a complicated history.

The only section of Wythering that can possibly be located today is south of Church Farm, Pagham, on the left by the path to Pagham Lagoon. This lagoon was once a millpond that was used for Pagahm Tide Mill. There is now a caravan site here. There are vague bumps in the area, which may represent the site of houses of Wythering, but it is possible that the main part of the place is now under the sea.

Shrunken Villages

Alciston

OS Grid Ref TQ 506 056

The village was a much larger place in medieval times until depopulation left a small settlement and its street being only half filled with cottages in a long straggling line. There was a line of homesteads in 1433 on both sides of the street to the Lewes to Eastbourne highway, which is now a bridleway. The only surviving masonry of one of the houses is a fragment of flint walling and the platforms on which the houses stood can be seen.

There are earthworks in fields north of the Norman church, which probably represent house sites. A number of the remaining cottages have thatched roofs

Church and ruins of medieval dovecote, Alciston.

and some are timber-framed. There is a medieval tithe barn and the remains of a dovecote. Excavations at the church in 1984 revealed remains of an apse from an earlier pre-Norman Conquest building.

Aldingbourne

OS Grid Ref SU 924 055

The village of Aldingbourne was a much larger place in medieval times and probably declined in size during the Black Death. There are earthworks of former cottages near the church and other slight humps in other fields nearby. Caedwalla (King of Wessex) granted 87 hides of land in Aldingbourne and other nearby places in 683. Aldingbourne is mentioned in the Domesday Book where a church is recorded. There are a number of old cottages along Church Road.

Arlington

OS Grid Ref TQ 543 075

The shrunken village of Arlington has only a church and several houses, which are widely spaced. There are extensive earthworks in the form of mounds and irregularities south and west of the church, where pottery possibly dating to the twelfth century has been found. An estate map dated 1629 shows buildings that mostly still stand or their sites are today occupied by later ones. Of these buildings the old parsonage house and a pond are included. The site is now depicted by mounds. The village was probably shrunk in the fourteenth century.

Earthworks of shrunken village west of the church, Arlington.

Beddingham

OS Grid Ref TQ 445 078

Beddingham near Lewes was once a larger place and field surveying in 1983 has traced old trackways, banks and ditches, as well as house platforms around the church. These are visible today as earthworks. On Budgeon's map of 1724 a windmill is shown south of the church on Beddingham Hill. The village probably declined in size during the Black Death. A Saxon nunnery adjoined the church. There are still a number of houses in the village.

Berwick

OS Grid Ref TQ 521 052

Today Berwick is only a fragment of a much larger village and more than 100 years ago Allcroft said, 'Under its grass fields you may see the steads of a multitude of buildings that have vanished'. Earthworks are visible today north and west of the church just south of the A27 main road. In a field called the Tye (a Sussex term for 'village green') earthworks of buildings and a line of a former street can be seen. The field is under grass and has not been ploughed.

There are several buildings in the village and the Cricketers Arms dates from the sixteenth century. A field east of this inn was where the original village once stood. It is said that most of the village vanished as a result of the Black Death or bubonic plague of the mid-fourteenth century.

Mound in churchyard said to be a plague burial ground, Berwick.

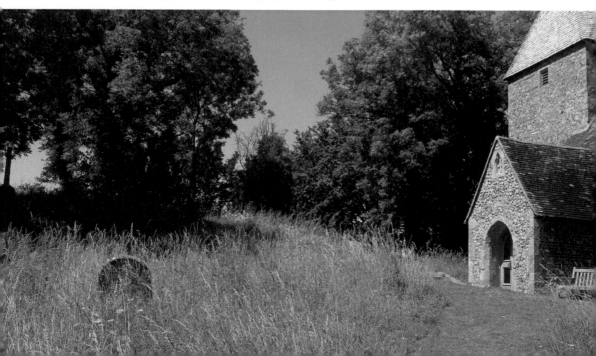

Binsted

OS Grid Ref SU 982 061

There are house platforms on the road down to the Black Horse pub and earthworks on both sides of the road. In a field south of the inn and opposite the Glebe House are irregularities and earthworks. There are also earthworks north and west of the twelfth-century church, but the field south of it has been ploughed. It is not known when the village diminished in size. There are several houses of interest in the village. The pub was built on an Iron Age ditch and is partly timber-framed.

In the summer of 1964 digging was carried out to make a garden and various pieces of pottery, tile and a medieval kiln were found. It was a pottery kiln and had been in operation between 1215 and 1315. The Binsted Kiln was sited on the old highway between Arundel and Chichester, which is now an overgrown path called Old Scotland Lane. Excavations were carried out from May 1965 and vast quantities of pottery, green glazed tableware and cooking pots were also found.

Bishopstone

OS Grid Ref TQ 427 010

Bishopstone was mentioned in the Domesday Book as 'Bicopestone' which means 'land of the Bishops of Chichester'. The village was once larger and depopulation was probably due to the Black Death. There were twenty-one landholders in 1591

Shrunken village from Rookery Hill, Bishopstone.

and by 1685 only fourteen. Today there are a few buildings and one is the manor house, which has 'Pelham Buckle' on its wall with the date 1688.

There was a bishop's grange or residence south of the church and it is said that the village possessed the first windmill in England. Bishopstone Place stood where there is a graveyard today. The cellars of the house still exist beneath the graveyard and the house was demolished in 1831. In the adjacent field west of the church are a few irregularities where houses once stood. Next to the church is Eadric House. The church is Saxon in date.

Bodiam

OS Grid Ref TQ 785 259

The Wealden village of Bodiam was a much larger place in medieval times and there are only a few earthworks on the site today to show its former extent. The Romans built a harbour at Bodiam and Romano-British and Saxon settlements existed here. The shrinkage of the village probably occurred in the Middle Ages, and there are several old buildings still standing. The church, dedicated to St Giles, dates from the thirteenth century. There is a headless and legless brass dated 1360 in the church.

The main point of interest in Bodiam is its medieval castle, built by Sir Edward Dalyngrigge in the fourteenth century. It was described by Lord Curzon of Kendleston as a fairy castle, but it is known as a courtyard castle and there are only a few of its kind. Bodiam Castle has various apartments around a central court. Other than during the Civil War in the seventeenth century, the castle was never attacked.

Clapham

OS Grid Ref TQ 096 067

Clapham was an important village in the Middle Ages, but today only consists of a single street and the church is reached by a footpath. There are earthworks and a hollow way to the south of the church and farm, which represent the site of former houses and a street. There were probably houses around the church in medieval times and there are possible house platforms in nearby woods. The footpath going north of the church may have been a street and this goes to the left into a field and to the right in the woods is a good hollow way, which may have been part of the street.

Clapham has a number of old buildings in The Street, some of which are timber-framed and thatched. There are several modern houses and roads in Clapham today. Church House is believed to have been the manor house and one old cottage, which was derelict for many years, has been renovated.

Above: Old oak tree said to have been in centre of the village, Clapham.

Below: Site of leper hospital at Lee Farm, Clapham.

The church, built in 1257, replaced an earlier Norman one. There is a thirteenth-century grave slab in the north aisle, which was originally in the churchyard. On the south wall is a small window that is said to be a leper window through which the priest administered the sacrament to lepers outside the church. Lee Farm, some 3 or 4 miles north-west of Clapham near Lower Barpham, was a medieval isolation hospital where victims of the plague were imprisoned. There is a path leading from the farm to the church known as 'Lepers Path' and this is where the lepers used to walk to church for services.

Climping

OS Grid Ref TQ 003 024

Climping was a much larger place in medieval times and probably shrank in size as a result of the Black Death. There are earthworks and inequalities in fields south of the church and east of the road, which may be former house sites. The layby by the Norman church was probably once the village street. The earthworks south of the church are believed to be of a Saxon settlement. The fields to the south-east of the church have suggestions of house platforms and hollow ways. A trial cutting was made by bulldozer through various banks and depressions, revealing brick and stone walling and also sherds of medieval pottery.

Donnington

OS Grid Ref SU 852 022

The village of Donnington probably declined in size during the Black Death in the mid-fourteenth century. There are slight humps in fields north and south of the church where houses once stood. Footpaths to the church were possibly lanes at one time. There are several houses at the southern end of the village along the B2201 road and also north of the church by Donnington manor.

East Chiltington

OS Grid Ref TQ 369 152

The village of East Chiltington probably declined in size in the Middle Ages leaving several houses and a twelfth-century church. There are earthworks in the form of house platforms north of the church and some earthworks east and west of it. Slight earthworks also exist along the lane east of Chapel Cottages. The lane runs along the line of a Roman road.

The footpath, which runs westwards to the north of the church, may have once been a street in the village. Some 2 miles to the east is Chapel Farm, which

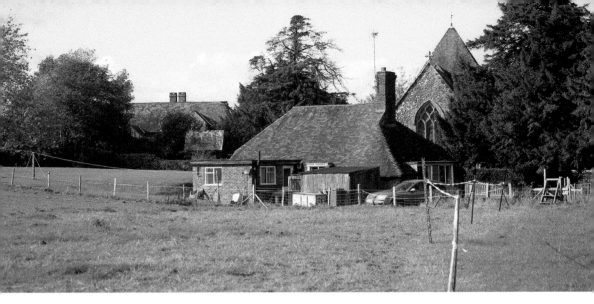
A few remaining cottages near the church, East Chiltington.

was named from a modern chapel. It is said that victims of the Black Death were buried in the fields around it. The modern chapel no longer exists.

East Dean

OS Grid Ref SU 904 132
East Dean village probably declined in size during the Black Death. There are a number of earthworks representing house platforms in fields around the church. Several old cottages still exist in the village today and The Hurdlemakers Inn was named from a local craft, which was a thriving trade in the nineteenth century. This pub is now called The Star & Garter.

Edburton

OS Grid Ref TQ 233 115
Edburton is Edburga's Town, which was named after Princess Edburga, who was born around AD 900. She was the daughter of King Edward the Elder. The village of Edburton was once larger in size than it is today and there are only scattered cottages in the village now, some of which are partly timber-framed. There are no earthworks to show the extent of the original village apart from vague bumps in fields around the church.

The church, dedicated to St Andrew, was built in around 1180 on the site of a Saxon one. Stones from the old church were incorporated into the present building. The tower was built in around 1375. It is possible that there was an industry (such as iron) some 1,000 years ago judging by the length of the church,

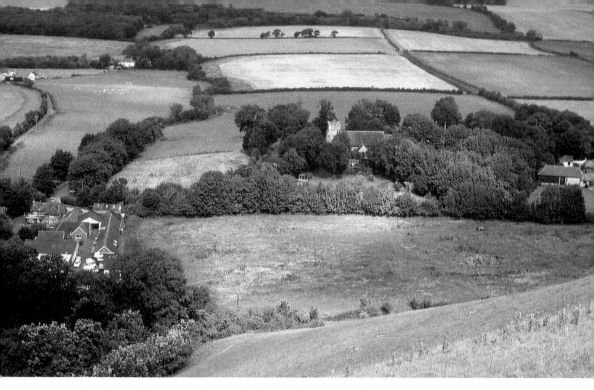

Shrunken village from the top of the South Downs, Edburton.

but the village around it probably declined in size during the Black Death. The main point of interest is the four mass clocks, which are vertical sundials and are Saxon in date.

On Eburton Hill are the earthworks of a Norman motte-and-bailey castle. This is known as 'Castle Rings' and is near Iron Age and Romano-British settlements. It consists of a mound and a rectangular bailey. This motte-and-bailey castle was probably in use for only a few years and possibly had a timber structure. It is some 300 feet above the village and must have been a task to reach, but also on the hill further east is the site of Perching village, which it probably served.

Hardham

OS Grid Ref TQ 038 176
Hardham is around 1.5 miles south of Pulborough and was a larger place in medieval times. When the main A29 road was being built in the 1930s, it was cut through probable house sites and a vast quantity of medieval pottery was found. The new road bypassed Hardham church and the remaining houses near it. There are slight irregularities north of the old London Road and south of the present main road. Today there are several houses in the village, two of which are timber-framed on either side of the church and one of them is 600 years old. One of these was once a mint.

Shrunken village site with church and cottage, Hardham.

The church, dedicated to St Botolph, dates from the eleventh century. The most interesting thing in the church is the twelfth-century wall paintings, which are a picture bible. They were discovered in 1862 when plaster was chipped off the chancel arch. The wall paintings cover the nave and chancel. South of the village are the remains of Hardham priory, which was founded by William Dautrey in 1248 and built for the Black Canons of St Augustine.

Hunston

OS Grid Ref SU 865 015
Hunston is a possible shrunken village as there are only a few houses in it. The houses and church are in Church Lane, but there is only a farm and manor house in the vicinity of the church. There are many houses on the B2145 Chichester to Selsey road, but these are modern. Today earthworks exist on either side of Church Lane just off the B2145, which may well represent house sites and there are vague bumps east of the church, but other fields in the area have been ploughed.

The manor house dates from the seventeenth century and was surrounded by a moat, of which parts still remain. It is said that the original goes back to the Domesday Book and monks lived in it at one time. The church north of the house was largely rebuilt in 1885 and the first church dates before 1105. The old church had a south aisle but there is not one today, and as the new church was built in the same position as the old, it means that the vaults that were in the south aisle are now outside the church. The old church had a tower.

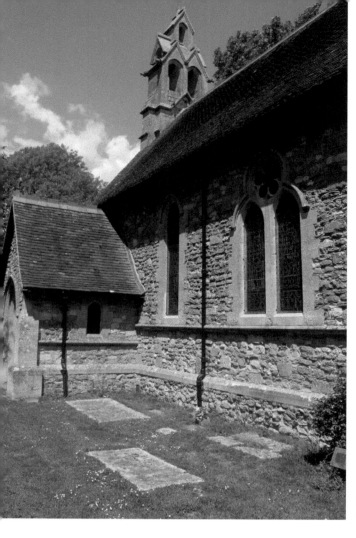

Site of south aisle and vaults,
which were inside it, Hunston.

Hurstpierpoint

OS Grid Ref TQ 279 165

Today Hurstpierpoint is a main village that has grown considerably, but it is listed
as a shrunken medieval village because it had a period of desertion and there are
extensive earthworks to the south of the church on either side of the B2117 road
to show where it once stood. The village grew along the B2116 road and to the
north of it. There are many buildings of interest in the village.

The church, dedicated to the Holy Trinity, was built in 1843 to 1845 on the
site of the old St Lawrence's Church. The first church could well be pre-Norman
Conquest. There are items from the old church in this newer one and in the nave
is an effigy to Simon de Pierpoint. The new church was built around him and his
figure is represented on the village sign. In the north aisle is a mutilated effigy of a
medieval knight (*c.* 1340), which has a dog by his head and a lion at his feet.

Earthworks of former village south of the High Street, Hurstpierpoint.

Merston

OS Grid Ref SU 894 027
Merston village was a larger place in medieval times and sherds of pottery were found on the site. A number of buildings still exist north of the church, one of these being a timber-framed rectory dating from the fifteenth century. There are earthworks in fields west of a house called 'The Whitehouse' and east of a barn in the northern part of the village. The field east of the road north and south of the church has been ploughed.

Ovingdean

OS Grid Ref TQ 355 036
There are several houses in the village of Ovingdean today including a coach house, old tithe barn, rectory and a church. The village has no public house. Ovingdean is around a mile inland from the sea along a dry riverbed. This terminates in a coombe at the head of the old river valley. In a field to the north of the church are a vast number of earthworks representing the site of former houses. The village probably declined in size in the Middle Ages. Excavations were carried out on the site from 2014 to 2017, revealing sites of buildings. One of these was the manor house.

The church dates from the eleventh century and originally had a south aisle and thirteenth-century chapel, both of which were destroyed by fire in 1377 during French raids. The church is dedicated to St Wulfran, one of only two churches in Britain dedicated to him. The other is at Grantham in Lincolnshire, which is like a small cathedral.

Pagham

OS Grid Ref SZ 883 975

The village of Pagham was a larger place in medieval times and probably declined in size during the plague. There are only slight irregularities in the area around the church, where the village once stood. Several old houses still exist in Pagham and the one opposite the church is a cottage dating to the twelfth or thirteenth century.

Beckett's Barn, south of the church, was once a tithe barn dating to the late thirteenth or early fourteenth century and is now in use as a reception for a holiday and caravan park. West of the church by the harbour are the vicarage and a house called Little Welbourne. On Pagham Harbour is a salt house. The church was built in the twelfth century on the site of a Saxon building. Foundations of the Saxon church were found when the floor was relaid in 1976.

In the garden of Little Welbourne are the remains of St Andrew's Chapel. This chapel was built in Saxon times and is mentioned as 'The church of St Andrew as

Old cottage opposite the church, Pagham.

on the east bank of the harbour' in Caedualla's charter. It was known as 'Uedring Mutha'. The only remains are a wall between nave and chancel. The arch and windows are blocked. A tower existed at one time, which would have fallen into the harbour. The chapel can be seen from the harbour.

Pevensey

OS Grid Ref TQ 648 048

The Romans built their fort of Anderida at Pevensey in the third century AD. It is one of the chains of Roman forts built along the coast between Norfolk and Hampshire to defend the coast from attacks by Saxon raiders. Pevensey was an important seaport and a limb of the Cinque ports of Hastings. In the south-east corner of the Roman fort is a Norman castle.

The village had three parallel streets in the Middle Ages and there was a decline in the fourteenth century. By the fifteenth century the sea receded and there were only twenty houses left in the sixteenth century. Today Pevensey is around 2 miles inland. The Pevensey Levels was once under the sea and there were islands on it, which is shown by the names of Rickney, Northeye, Chilley, Horse Eye, etc., 'Eye' means an 'island'.

There is a single street (High Street) and a small lane by the church today. The area south of the church is wooded where the third street was, and west of this are irregularities. There are vague bumps in the recreation ground to the south of the wooded area. East of the church is Glebe House and south of it is the foundation and earthworks of a building. In the High Street are some old houses and Ye Old Mint House is 600 years old.

Poling

OS Grid Ref TQ 046 045

There are traces of the village to the south of and parallel to the modern village street and west of the church. House platforms survive as cropmarks on either side of a slightly sunken trackway. There are marks north and west of the church and bumps in a field opposite Peckham Lodge to the north of the village. Hollow ways near and west of the church may have been lanes and there is also a moated site. The footpath, which goes west to east from Lyminster to Angmering via Poling, may have once been a main route in medieval times and could also have been a Roman road. It was also a medieval drove road.

Many buildings of interest still exist in the village. Around half a mile north of the church is Fair Place Farm, built on the site of a preceptory (Knights Hospitallers), which was probably founded in the twelfth century and dissolved in 1540. There are some thirteenth century remains on the site today and now in use as a house. The parish church is of Saxon origin.

Street and cottages in the shrunken village, Poling.

Southease

OS Grid Ref TQ 423 053

Southease was once a fishing village when the River Ouse was wider and closer to
the village. Southease once had a quayside and was a thriving place at the time of
the Domesday Book. The pool in the grounds of Southease Place may have once
been a busy harbour. It was assessed for 38,500 herrings and at £4 per porpoise.
The village was larger in medieval times and slight irregularities are to be seen in

Church with its round tower and a few cottages, Southease.

fields south of Meadow Cottage to the east of the Lewes to Newhaven road. There were a number of farms in the village, but only two remain today. The village once had an alehouse, which exists today as a house called The Rest.

The church has a Norman round tower, which is one of three in Sussex – all in the Ouse Valley. The others are at St Michael's in Lewes and at Piddinghoe near Newhaven. Southease church was once larger and is said to have been destroyed in the fourteenth century. This is probably due to the village having declined in size. There are ancient wall paintings in the church. The churchyard was probably a pagan site and five skeletons were found in 1851, facing north to south.

South Heighton

OS Grid Ref TQ 451 028

South Heighton had twelve landholders in 1623 and only four in 1753. The village probably shrank in size at the time of the Black Death in the mid-fourteenth century. There are earthworks in a field opposite South Heighton Farm, which could represent the site of former houses. There are a number of interesting houses in the village.

The old church, dedicated to St Martin, was high on the hilltop on a site south of the Hampden Arms public house. It was struck by lightning and gutted by fire in 1769. One wall of the church was still standing and a few graves were still there in the eighteenth century. The basin of the font is now in Chiddingly church. The inside of South Heighton church and cemetery were used as a garden.

In the latter part of the nineteenth century a building was built on the site known as 'The Hall'. This was demolished in the year 2000 and a couple of houses occupy the site today. The ruins of the church were marked on an 1879 map south of the Blacksmiths Arms Inn. This public house is now a cottage called 'Badgers Hill' and it is north of the present inn.

Stanmer

OS Grid Ref TQ 337 096

The village of Stanmer consists of a street running north to south and was a larger place in medieval times. There are irregularities in Stanmer Park, which represent the site of the former village, which was lost during the bubonic plague of the fourteenth century. The existing village north of the church has several cottages, a farm and tearooms. There are also slight irregularities in a field opposite the latter, which may represent the site of houses.

The medieval church, dedicated to St Leonard, was rebuilt in 1838. The original fourteenth-century church stood in the churchyard to the north, although the arch of its doorway was incorporated into the new church. A church has existed on this site since Saxon times.

Next to the church are a lake and also a well house, which was dug in the sixteenth century. The well is 252 feet deep. In the well house is a donkey wheel that is 13 feet in diameter, which was powered by a donkey until 1870 and then by people until 1900. Stanmer Place, nearby, was built by Henry Pelham in 1722 and it is now a bar and restaurant.

Tarring Neville

OS Grid Ref TQ 443 039

This village was mentioned in the Domesday Book as 'Toringes'. Neville was added to the name after the Neville family, who owned the parish. Alternatively, the village is named East Tarring. There are around seven cottages, two farms and a twelfth-century church in Tarring Neville today and it is thought that the Black Death was the cause of depopulation. There are some earthworks in adjacent fields, which probably mark the site of former houses of the village.

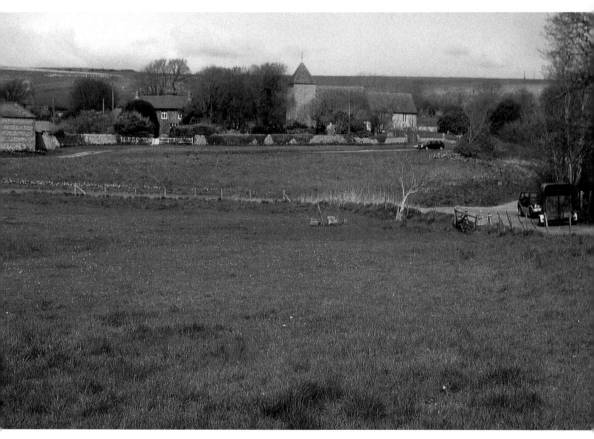

Church and a few cottages, Tarring Neville.

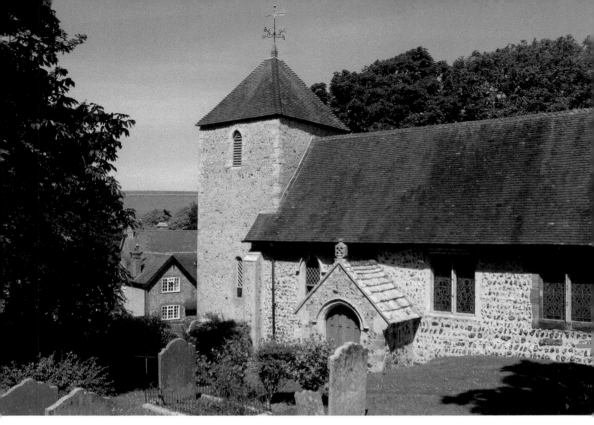

Church on a hill above main village, Telscombe.

Telscombe

OS Grid Ref TQ 405 033

The village of Telscombe, tucked away in a valley, declined in size during the bubonic plague. A number of old cottages remain along the village street. There are earthworks representing possible house platforms in fields in the southern part of the village and in an open space north of the twelfth-century church. The road to Telscome from Southease ends at the village and becomes a footpath towards the beach, which probably was once the continuation of the road in medieval times.

Walberton

OS Grid Ref SU 971 056

The village of Walberton probably declined during the Black Death in the mid-fourteenth century. There are earthworks in fields west and north of the church where houses once stood. The fields south of the church show no sign of any noticeable earthworks due to ploughing. Several old cottages still exist in the

Old stone coffin inside the church, Walberton.

village, some of which are thatched, and there is also a medieval cattle pound. At the western end of the village is a pond. In the twelfth-century church (on the site of a Saxon one) is a thirteenth-century stone coffin, which was found in 1834 while digging an underground drain.

Wepham

OS Grid Ref TQ 045 085

The village of Wepham, near Arundel, was mentioned in the Domesday Book as 'Wepeha'. The village probably declined in size during the Middle Ages. There are a number of earthworks representing house platforms in a field west of the main village. Medieval pottery was found on the site. The village has a number of cottages, some of which are thatched. There is a house called The Granary and there are some thatched barns. Wepham Cottage is also thatched. A tide mill once existed in Wepham but only the millpond remains today. A Southern Water hut stands on the site of the tide mill today.

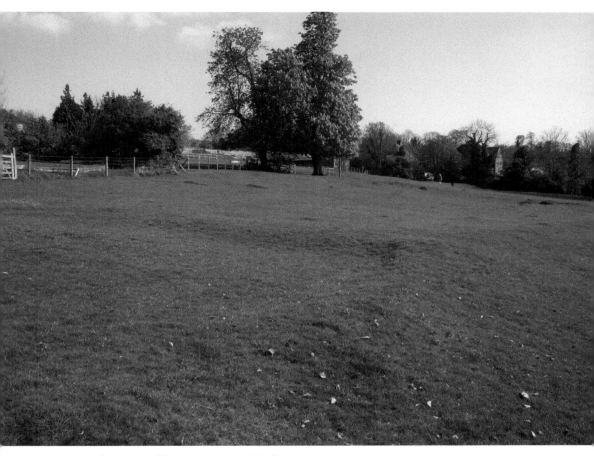

House platforms of former cottages, Wepham.

Winton

OS Grid Ref TQ 520 038
The hamlet of Winton near Alfriston is mentioned in the Domesday Book as 'Wigentone' and was derived from the old English 'Wigington'. A single cottar is recorded at Winton in 1086 and the hamlet was a larger place in the Middle Ages. There are several cottages remaining in Winton today, some of which are timber-framed and thatched. Danny Cottage has got a thatched garage.

There are slight irregularities north of little Winton House and Old Farm Cottage, west of the B2108, but fields at the western end of Winton have since been ploughed. There were probably houses at this end of the village where footpaths meet, as there are humps and bumps south and north of Winton Street. Some of these footpaths may have once been roads connecting Winton with other villages.

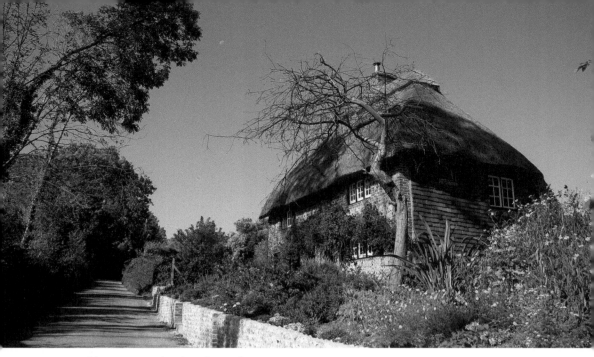

Old cottage in the shrunken village, Winton.

Yapton

OS Grid Ref SU 979 035
There are earthworks and depressions in fields south of the church, which represent the remains of the medieval village of Yapton. The village declined in size in the Middle Ages. There was a manor in Elizabethan times and Yapton Place was reconstructed in 1800, but it was demolished by 1829. There is no trace of Yapton Place today and the dovecote and outbuildings are still in existence. Fields north of the church have been ploughed. There are several old cottages in Yapton to the west of the church. The Shoulder of Mutton and Cucumbers Inn achieved its name by specialising in shoulder of mutton and cucumber. It was the longest pub name in Sussex. It is now a private house.

The old church at Yapton is dedicated to St Mary the Virgin. The tower and south aisle slipped and are leaning at an angle of some eleven degrees. This can be seen by the tower window and east window of the south aisle. There are carvings on the pillars of the north aisle, but there are uncompleted carvings on one pillar of the south aisle, but not on the others. This was due to the men going to work on Chichester Cathedral, who did not return to Yapton afterwards.

SHIFTED VILLAGES

Albourne

OS Grid Ref TQ 257 162

There are only three houses and a church in Albourne today. Albourne Green is an extensive community around half a mile north-east of the church. People probably migrated to this new site from the area of the church when the land was emparked, but the period of migration is not known. Today there are no visible

Medieval cattle pound, Albourne.

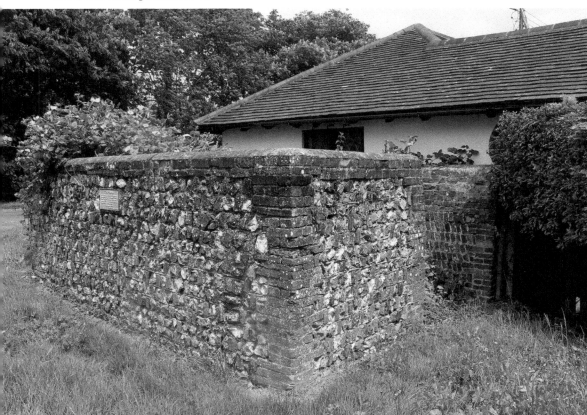

remains of the former village around the church as the site is now ploughed. There are some interesting houses in Albourne Green and also a medieval cattle pound. The church, dedicated to St Bartholomew, stands near Albourne Place and dates from the Norman period.

Barcombe

OS Grid Ref TQ 418 143

The original village of Barcombe was around the Norman church and was ravaged by the plague. Many houses were burnt down, leaving only a few still standing. One of these, opposite the church, Penance House, was originally two cottages. There is an interesting thatched round house in the village. There are earthworks in fields south of the church where houses once stood. It is said that the war memorial in the churchyard stands on a mound, which is believed to hold victims of the plague.

The present village was built on a new site around a mile north of the church and is known as Barcombe Cross. There is a pleasant High Street with tile-hung cottages and many buildings of interest in the village. The old forge dates to 1560. To the south-east of Barcombe Cross is Barcombe Mills, but no mills exist here today. They were situated on the River Ouse.

Earthworks of the former village, Barcombe.

Buxted

OS Grid Ref TQ 486 231

Buxted has a thirteenth-century church built in 1250 on the site of an earlier one. It is situated in Buxted Park and has no other building nearby. The medieval village, which was once around the church, was removed in the 1830s by the owner of Buxted Park, Lord Liverpool, to enable him to enlarge the park. Lord Liverpool offered to construct new buildings for the villagers if they were to go elsewhere in the parish. There was a parsonage, shop, forge, inn, stocks and a whipping post near the church.

The new village, around half a mile to the east, is a flourishing community and has many buildings of interest. The new church was built in 1885. At the site of the old village there are hollow ways with house platforms going north and west of the church. The latter runs westwards across the park to a stream where a few sherds of medieval pottery were found. There was an avenue of trees along this hollow way, which were blown down in the great hurricane of 16 October 1987.

The other hollow way going north-east from the church is not easy to see. Grave digging in the north part of the churchyard has destroyed nearly all signs of the village street, but there is an ancient yew tree standing on a mound and probably on one side of the hollow way, which forms the street. The deserted site was discovered due to a pile of earth on the east wall of Buxted church, which was surplus soil from grave digging some 40 yards north-east of the chancel. Sherds of thirteenth-century pottery were found on the heap.

Hollow way of former street west of the church, Buxted.

Duncton

OS Grid Ref SU 960 170
Duncton is a straggling village that has grown along the busy A285 road. The village had shifted to this site at some uncertain date and the original village was further south where the present Church Farm buildings still stand. There was a manor, manor house, pigeon house, church and other buildings in the area. There are a few irregularities around which may represent the site of houses.

The site of the former village is suggested at the Grid Reference given, which is near the inn, and air photographs indicate a roughly rectangular enclosure south-east of the public house. The original site of the medieval village must have been near the church and by the Church Farm buildings mentioned above. The Cricketers Inn dates from the sixteenth century and was originally called The Swan. There are two cottages nearby and Duncton Mill was built around 1800 on the site of an earlier watermill.

The new church, dedicated to the Holy Trinity, was built in 1865. It contains a bell, which is the second oldest dated bell in England (1369). It is inscribed 'DE FLOTE A...E: LA: HAGUE; FET: LAN; MCCCLXIX.' It came from the old church and is thought that it was originally a navigational bell, which was captured by raiders in a Normandy port in 1377. The gate to the churchyard was made by schoolboys of the village in woodwork class.

The old church, dedicated to St Mary, was around 1 mile south of the present church and was pulled down in 1876. It had only a single room and a bellcote. Duncton is mentioned in the Domesday Book where a church is recorded, which was probably on this site. Today, graves remain on the site with a dip where the church stood, which is all overgrown.

Findon

OS Grid Ref TQ 116 085
The original village of Findon stood around the church and manor house and shifted to its present site east of the church at some uncertain date. No medieval or Tudor buildings have been identified on the new site, but there is a house that dates from the late fourteenth century. The manor house next to the church is now Findon Place and the existing building is Georgian. There are many interesting buildings in the new village and the Gun Inn was once in part a gunsmiths.

There are no remains of the original village to be seen today due to much ploughing in the adjacent field, but there are cropmarks sometimes. The vicarage was north of the church in the seventeenth century. The church is Saxon and dates from 1055, which was long and narrow. The walls were tall and thin. Not long after 1100 a Norman church was built alongside it, using one wall of the Saxon church as its north wall. At the end of the twelfth century the wall between the

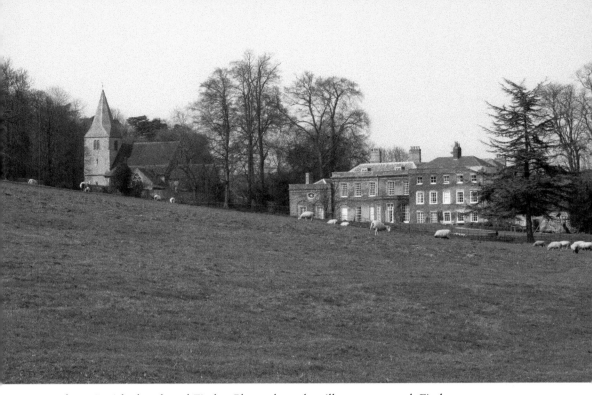

Above: Parish church and Findon Place where the village once stood, Findon.

Below: Pest House where plague victims were imprisoned, Findon.

two churches was pierced by an arcade, thus making the Saxon church into the north aisle of the Norman church.

Around 1.5 miles north-east of the church is a building called Pest House, which was at one time known as 'Pestilence House'. This name refers to the bubonic plague of the fourteenth century. During the plague, victims were taken to this house and were quarantined or imprisoned therein. It is believed that there are many hundreds of bodies in graves on the site. This suggests that Findon was deserted due to the Black Death.

Herstmonceux

OS Grid Ref TQ 643 103

The present village of Herstmonceux lies 2 miles north of the church. In 1441 Roger Fiennes was granted permission to empark 600 acres and it is suggested that this act led to the migration of the village to its present site. There are no visible earthworks of the original village to be seen around the area of the church and castle today. The church dates from around 1190 and was built on the site of an earlier one. The castle dates from 1440.

The present village, which has grown to a fair size, has some interesting buildings and the Woolpack Inn in the centre of the village was once a coaching inn. This is where local farmers took wool after sheep shearing. In 1870 a small church, dedicated to St James, was built in the village for those who were unable to go to All Saints. This was demolished in the 1980s.

Hooe

OS Grid Ref TQ 683 093

The village of Hooe, around 4 miles north-east of Pevensey, had suffered inundations from the sea in medieval times and the village was deserted. After the sea receded, a new village was built around a mile north-east of Hooe church, which is known as Hooe Common. At the old site around the church today there are only vague bumps in the adjacent field of the former village. In the new village are many houses that have associations with smugglers.

Isfield

OS Grid Ref TQ 443 181

Isfield church stands on its own around half a mile from the village, close to a motte-and-bailey castle. It could be that the original village stood around the church and was abandoned to be built on higher ground to escape flooding.

Hollow way of the main street, Isfield.

There are no definite traces of buildings, but there are irregularities in a field south of the church. There is a hollow way of the original street in this field. The motte-and-bailey near the River Ouse is visible today as earthworks and was a Norman castle. To the north of this is an enclosure of approximately 10 acres and is probably connected with the existing manor house north of the church.

The manor house dates from the sixteenth century and is known as 'Isfield Place'. To the east of this is a cattle pound, which is said to be the oldest in Sussex. The church dates from the Norman period, but was restored in 1876. The tombstone of William the Conqueror's daughter Gundrada (wife of William de Warene, who founded Lewes priory) was discovered under the floor in 1775 and it was returned to Southover church in Lewes. In the village of Isfield are scattered buildings.

Peasmarsh

OS Grid Ref TQ 888 218
The present village of Peasmarsh is on the Rye to Northiam road, around half a mile north of the eleventh-century church. There are no buildings near the church and the fact that it is isolated indicates that the village was once around the church and shifted to its present site, probably due to the Black Death. It is possible that the desertion could have been due to the land having been emparked around the church. There are some interesting houses in the village.

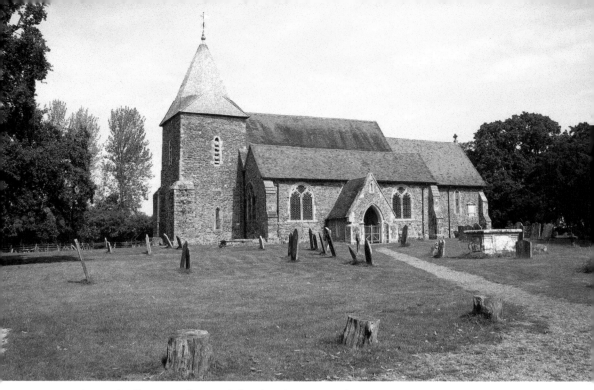

Original village stood around the church, Peasmarsh.

Pyecombe

OS Grid Ref TQ 293 126

The village of Pyecombe had suffered from the plague several times and declined at the end of the medieval period. The plague was so bad by 1603 that people moved out and resettled on a site a quarter of a mile from the church. There are several old cottages along Pyecombe Street, north of the twelfth-century church. There are no visible remains to be seen of the original village today as the site has been ploughed.

Selsey

OS Grid Ref SZ 871 958

The original town of Selsey stood in the area known as Church Norton and was mainly lost to the sea due to coastal erosion in the fourteenth century, leaving just a church. No sign of this old town can be seen today. A new town was built some 1.5 miles to the south sometime later, where there are some old cottages. This new town grew in size during the nineteenth and twentieth centuries and is now a popular seaside resort.

The church, dedicated to St Peter, in the new town was removed from its original site at Church Norton in 1866. Only the nave was taken down and moved, but

the chancel stood, which is now known as St Wilfrid's Chapel, Church Norton. The thirteenth-century St Wilfrid's Chapel probably stands on the site of a church, which existed in Saxon times.

In 681 St Wilfrid, Bishop of Northumberland, came to Selsey and built a cathedral at Selsey, which was dedicated to St Peter. This cathedral had a total of twenty-five bishops, but in 1075 the see was moved to Chichester. Like the town, Selsey cathedral was lost to the sea die to coastal erosion in medieval times. Nothing can be seen of the cathedral today, but rocks are exposed at very low tides every twenty years or so, which are reputed to be its ruins.

Shoreham

OS Grid Ref TQ 208 061
Shoreham is both a shrunken and shifted town. The original village and harbour (Old Shoreham) stood around the church, which was mentioned in the Domesday Book as 'Soresham'. The harbour silted up and the village declined in size. Several old houses still exist in Old Shoreham. The area around the church was built upon in recent times. The bridge over the River Adur to the west was once a toll bridge built in 1781.

A new town and harbour (New Shoreham) was sited around 0.75 miles south in 1100 and a church was built in 1103. This new town has a High Street with parallel grid streets coming from it in both directions. This harbour also silted

Site of original town of Old Shoreham and toll bridge, Shoreham.

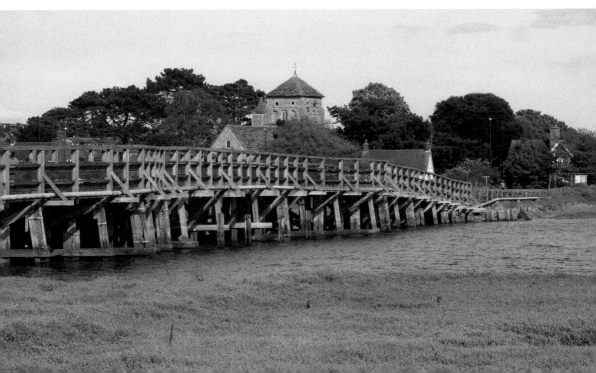

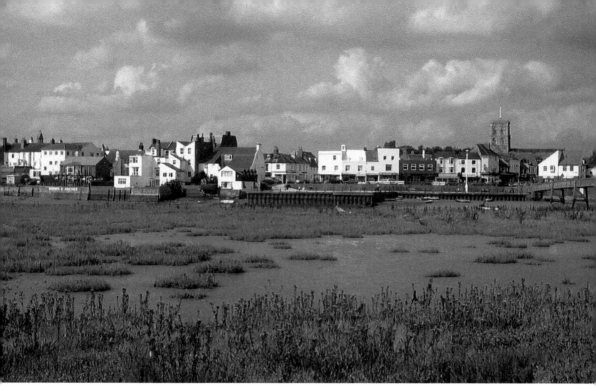

The southern part of New Shoreham lost in the estuary, Shoreham.

up and the southern end of the town, including the grid streets, was lost due to coastal erosion in medieval times. In the southern part of the town were a Templar and a Hospitaller priory. Only the northern end of the grid streets exists off the High Street. Only the ends of the grid streets on the southern side of the High Street still remain today. The large church is now half its size.

Besides the church the oldest building still surviving from the Norman town is The Marlipins, which dates from the twelfth century. Its use was probably for monastic or civil purpose. The building was owned by the Cluniac priory at Lewes in the early part of the sixteenth century. It has a chequered front and is now a museum. Ropetackle, at the western end of the town, was excavated in October 2000 and from January to May 2003. Medieval material was found dating to the thirteenth and fourteenth centuries, including pottery, brick and tile.

Sompting

OS Grid Ref TQ 162 056

The original village of Sompting stood around the area of the church and was probably deserted during the Black Death. There is little archaeological evidence of the former village, but there are vague bumps north and south of the church and possible house platforms to the north of the footpath, which runs east to

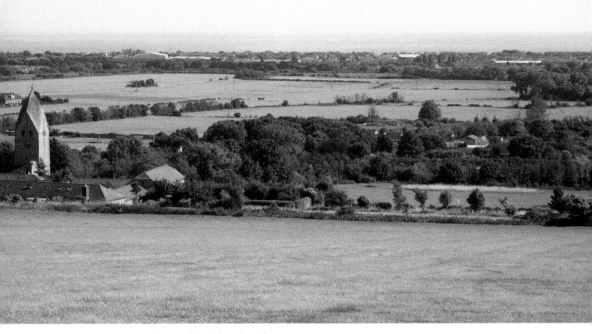

Shifted village to the south of the church, Sompting.

west. This footpath may have been a street of the village and it is said that it runs along the line of the Chichester to Brighton Roman road.

There is a hollow way that runs parallel with a footpath, going eastwards towards Lancing, that was probably once a lane. Saxon pottery dating to the tenth century has been found near the church. The present village is around a quarter of a mile south of the church and probably migrated here in medieval times. There are some interesting buildings in the village and it has two inns. One, The Marquis, is on the site of a Romano-British settlement. East of the church is a house called Sompting Abbots, which is now a boy's school.

The church, dedicated to St Mary, has a Rhenish Helm tower (Rhineland helmet) dating to the Saxon period, and it is the only one of its kind remaining in Britain. The church goes back to the Anglo-Saxon period and is cruciform in shape. North of the tower is a ruined medieval chapel of the Knights Templar and in the north wall of the nave is a blocked up doorway.

Steyning

OS Grid Ref TQ 179 114
Steyning is a picturesque small town in the Adur Valley, which was at one time the port of St Cuthman when the River Adur was navigable for ships. The sea receded around 1346 and Steyning ceased to be a harbour. The town probably

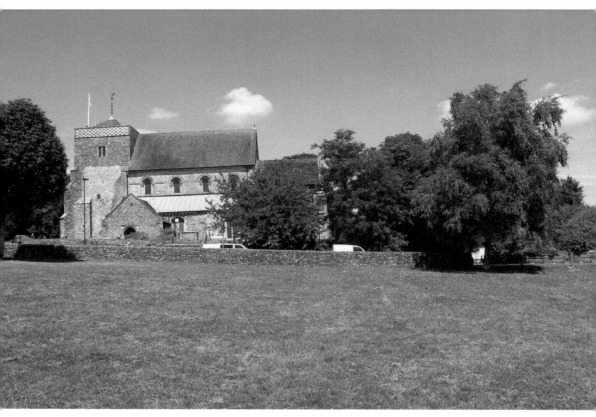

Site of original village and harbour near the church, Steyning.

declined during the Black Death. The main settlement was around the area of the church and was resited to the present High Street in medieval times. There are slight irregularities in open land south of the church where the original village once stood.

Excavations were carried out south of the church and the sites of houses were discovered, and in open fields east of the church are slight marks that are possibly the site of the harbour. There are many historic buildings in the village and one is the old grammar school, dated 1614. The clock face on the clock tower in the High Street came from a dovecote in Patching, which is now just a heap of rubble in Patching Woods.

The church dates from the Norman period and was built on the site of a Saxon one constructed of wood by St Cuthman which dates from the eighth or early ninth century. The Norman church is known as a collegiate church. The church was much larger in size and this can be seen at the east end of the chancel by a mound. In the porch is a Saxon gravestone to King Ethelwulf, who is said to be buried here in 858. His body was later moved to Winchester.

Upper Beeding

OS Grid Ref TQ 193 111

The original village of Upper Beeding stood around the church and was probably deserted by the Black Death. It was resited to the south along the present High Street where there are a number of old buildings. Some of these are timber framed and thatched. At the west end of the High Street the road crosses the River Adur on a medieval bridge.

The original village street probably went along Church Lane towards the church, where there are modern houses. Slight bumps exist along this lane, which may represent former houses, and there are possible house platforms at the west end. All houses in the vicinity of the church are modern.

The church, dedicated to St Peter, dates from the fourteenth century on the site of a Saxon one. Upper Beeding church was once a priory church for Sele priory, which was just to the north. This Benedictine priory was built in 1075 by William de Braose and the monks used the chancel of the church. Sele priory was dissolved in 1535 and the site is now occupied by a Georgian house. Masonry from the priory can be seen imbedded in the churchyard wall.

Shifted village and Beeding Bridge, Upper Beeding.

West Tarring

OS Grid Ref TQ 131 040

The original village of West Tarring stood in the area of the thirteenth-century church and was abandoned by the plague in the fourteenth century. It was resited a short distance to the east at a later date. Tarring was first mentioned in 941 and was 'Terringes' in the Domesday Book, where two churches are mentioned. The name Terringes still exists today in Terringes Avenue. This is an east to west road that has ancient origins.

There are slight irregularities in the recreation ground and park south of the medieval church, which may be the site of former houses and possible house platforms south-west of the church. Other possible house sites may be on a green area north of the churchyard. The rest of the area around the church is now built over.

Archaeologists excavated a moat in the vicinity some years ago, but not enough of it was found to determine whether it only surrounded just the church or the whole settlement. At the western end of the churchyard is a

Site of original village near the church, West Tarring.

dip in the ground, which could be part of the moat. The moat may have only circled the church and possibly a manor house.

The existing village in the High Street has a number of old houses and the most notable are Parsonage Row, which are a group of fifteenth-century cottages. The Archbishop's Palace in Glebe Road dates from the thirteenth century and the oldest part is the rectangular hall at the eastern end. It was originally a manor house. It had a single room on the upper floor and was extended in the early part of the fourteenth century, then widened in the fifteenth century.

Winchelsea

OS Grid Ref TQ 905 175

The original town of Winchelsea was a flourishing port and fishing village with a harbour, ship building yards, two churches (dedicated to St Thomas and St Giles), a Grey Friars, 50 Inns, mills and some 300 houses. The old town was being destroyed on several occasions by great storms in the 13th century and

The shrunken new town, Winchelsea.

was finally drowned by the waves in 1287. Old Winchelsea specialised in the wine trade with south-western French harbours. The site of the town is not certain, but the sea has receded since and the town's site may well be on dry land, which is cultivated marshland.

At the end of the thirteenth century a new town for Winchelsea was built near the village of Iham on Iham Hill by Edward I, who laid out a grid of streets with St Thomas' Church in the centre. This new town had another church, dedicated to St Giles, and a Grey Friars. After old Winchelsea was encroached by the sea, people moved to the new town in 1292. New Winchelsea flourished, but was not as successful as hoped for by Edward I. The plagues and French raids of the fourteenth century stopped the town's growth and St Thomas' Church was not completed. As the harbour to the north of the town silted up, Winchelsea declined to a small village.

Today there are a number of earthworks in fields south of the church and to the north of the ruin of St John's Hospital. There are many buildings of interest in the village and there are three hospitals in the south end of it. The town was once walled and fragments of three medieval gates still stand: the Strand Gate, New Gate and the Pipewell Gate.

In the north aisle of St Thomas' Church are three effigies that are older than the church. They are said to have come from the old church, which is now in the sea. Caen stone on the west wall is also said to come from the lost churches. St Giles' Church was lost by the sixteenth century. Nearby is a narrow lane called Dead Man's Lane, which was so named after 3,000 French invaded the town in 1350. People took refuge in the church but were butchered therein and buried in the churchyard. The Grey Friars is now a ruin.

BIBLIOGRAPHY

Allison, K. J., *Deserted Villages* (Macmillan & Co. Ltd, 1970)

Beresford, M. W., *The Lost Villages of England* (Lutterworth Press, 1954)

Beresford, M. W., and Hurst, J. G., *Deserted Medieval Villages* (Lutterworth Press, 1968)

Brandon, P., *The South Downs* (Phillimore, 1998)

Brandon, P., *The Sussex Landsacpe* (Hodder and Stoughton, 1977)

Burleigh, G. R., 'An introduction to deserted medieval villages in East Sussex', *Sussex Archaeological Collections (SAC)*, Vol. 111 (1973), pp 45–83

Burleigh, G. R., 'Further notes on deserted and shrunken medieval villages in Sussex' *SAC*, Vol. 114 (1976), pp 61–68

Driver, L., *The Lost Village of England* (New Holland Publications, 2006)

Holden, E. W., 'Excavations at the deserted medieval village of Hangleton, Part I' *SAC*, Vol. 101 (1963), pp 54–182

Hurst, J. G., and Hurst, D. G., 'Excavations at the deserted medieval village of Hangleton Part II', *SAC*, Vol. 102 (1964), pp 99–142

Lucas, B. H., 'Northeye: A Lost Sussex Town', *Sussex County Magazine (SCM)*, Vol 6 (July 1932), pp 464–465

Lyndhurst, D., *Bishopstone and the Lost Village of Tide Mills* (SB Publications, 2008)

McCarthy, E. and M., *Sussex River, Journeys Along the Banks of the River Ouse: Newhaven to Lewes* (Lindel Organisations Ltd, 1977)

McCarthy, E. and M., *Sussex River, Journeys Along the Banks of the River Ouse: Upstream from Lewes to the Sources* (Lindel Organisations Ltd, 1979)

Martineau, G. D., 'The End of Old Winchelsea', *SCM*, Vol. 24 (October 1950), pp 442–443

Muir, R., *The Lost Villages of Britain* (Michael Joseph, 1982)

Muir, R., *The Villages of England*, (Thames and Hudson Ltd, 1992)

Reeves, H. L., *Adur to Arun* (Sheepdown Publications, 1970)

Rowley, T., and Wood, J., *Deserted Villages* (Shire Publications, Third Edition, 2000)

Skinner, D., *Sussex: People and History* (The Crowford Press, 2002)

Taylor, C., *Village and Farmstead* (George Philip, 1983)

Turner, E., 'The Lost Towns of Northeye and Hydneye', *SAC*, Vol. 19 (1867), pp 1–35

Vigar, J., *The Lost Villages of Sussex* (Dovecote Press, 1994)

Vincent, A., *The Lost Churches and Chapels of Sussex* (SB Publications, 2005)

Vincent, A., *Lost Villages of Sussex* (Three Fold Leaflet, 2002)

Walker, C., and Vincent, A., *Records of the Past 2* (Charles Walker, 1989)